Millie Marotta

Beautiful Birds
and Treetop Treasures

LARK
New York

An Imprint of Sterling Publishing Co., Inc.
1166 Avenue of the Americas
New York, NY 10036

First published in the United Kingdom in 2017
by Batsford, an imprint of Pavilion Books Group Ltd., as
Millie Marotta's Beautiful Birds and Treetop Treasures: A Colouring Book Adventure

ISBN: 978-1-4547-1018-9

Distributed in Canada by Sterling Publishing Co., Inc.
c/o Canadian Manda Group, 664 Annette Street
Toronto, Ontario, Canada M6S 2C8

For information about custom editions, special sales,
and premium and corporate purchases, please contact Sterling
Special Sales at 800-805-5489 or specialsales@sterlingpublishing.com.

Manufactured in Singapore

2 4 6 8 10 9 7 5 3

larkcrafts.com

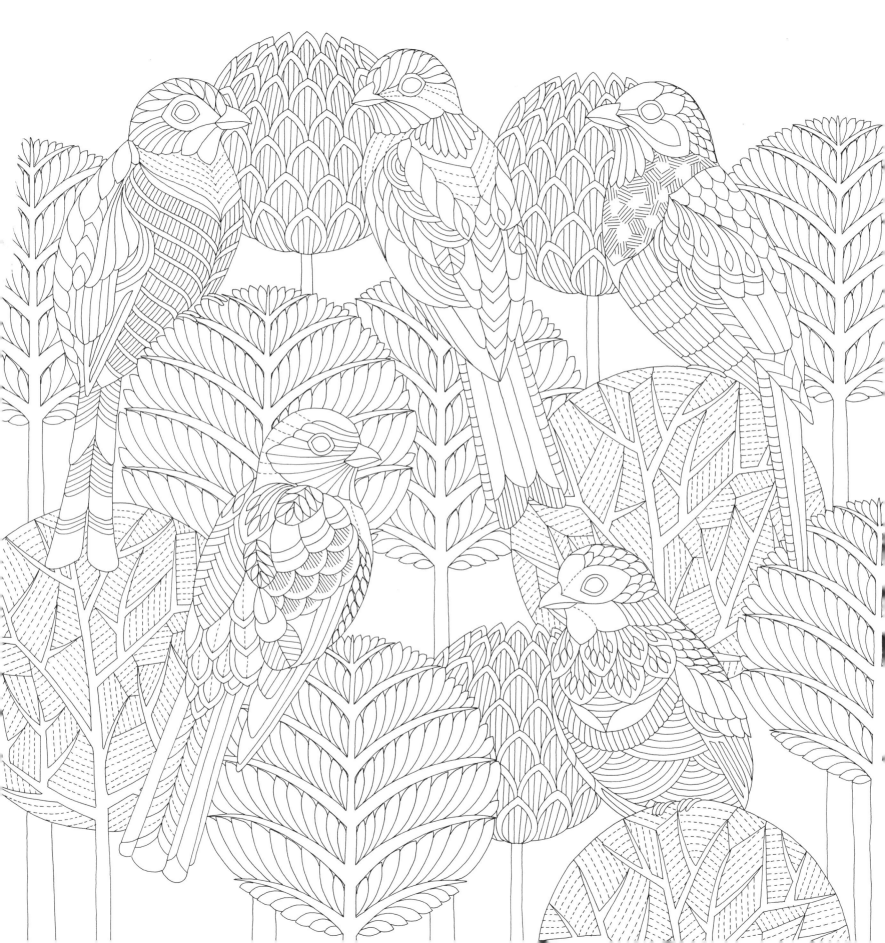

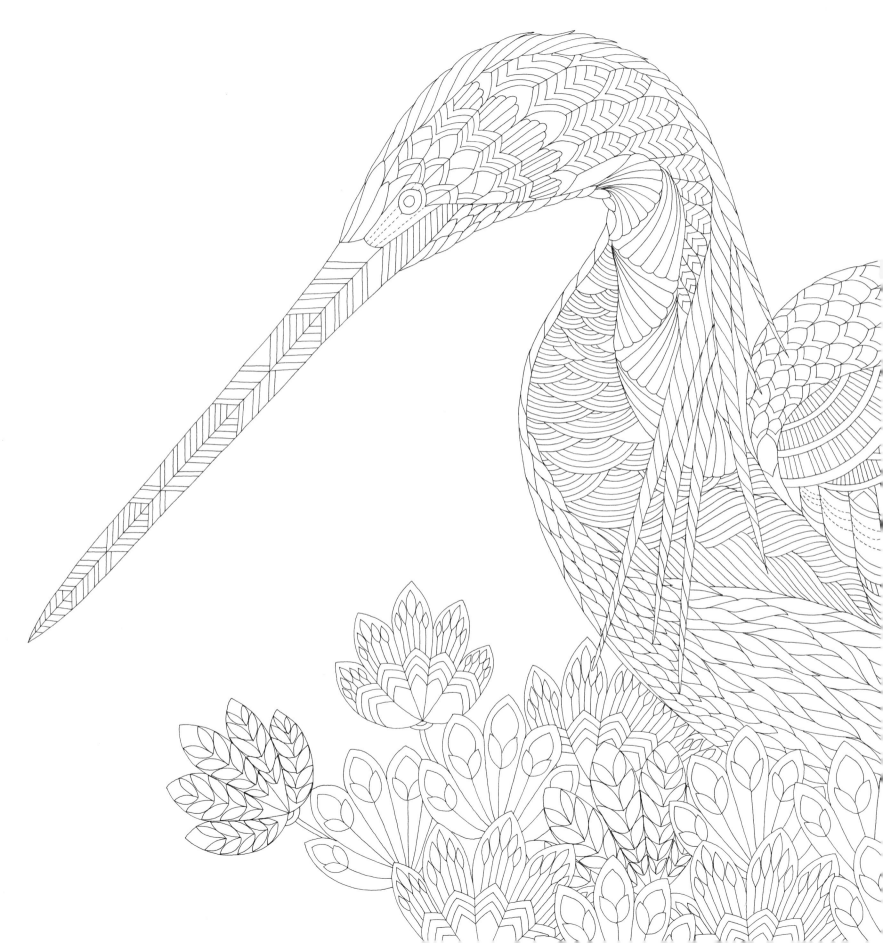

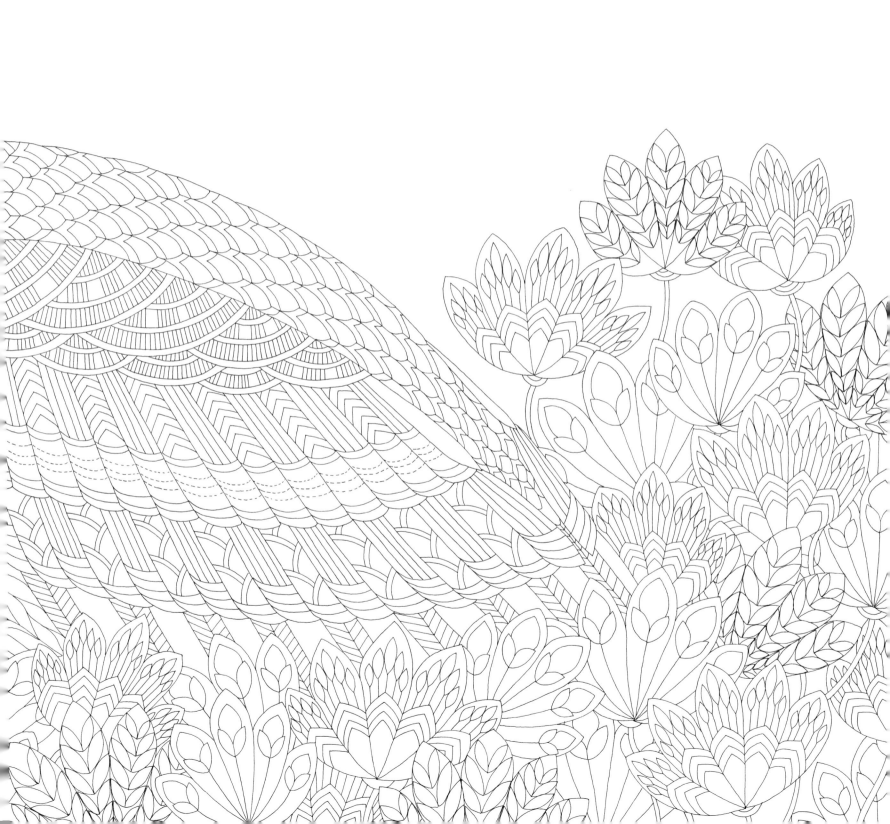

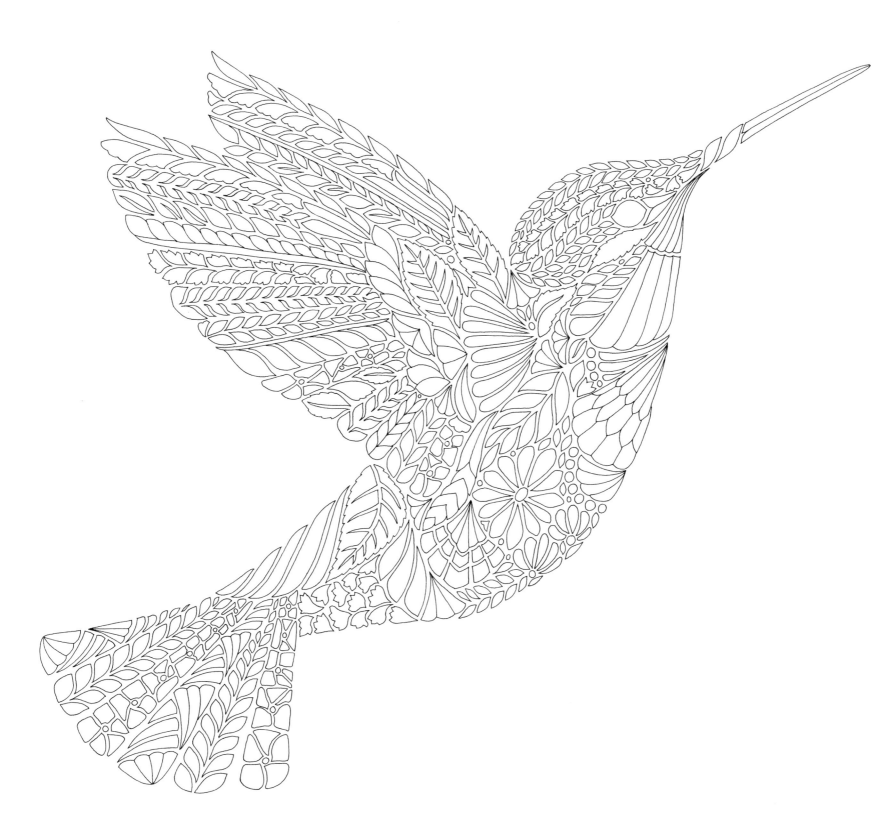

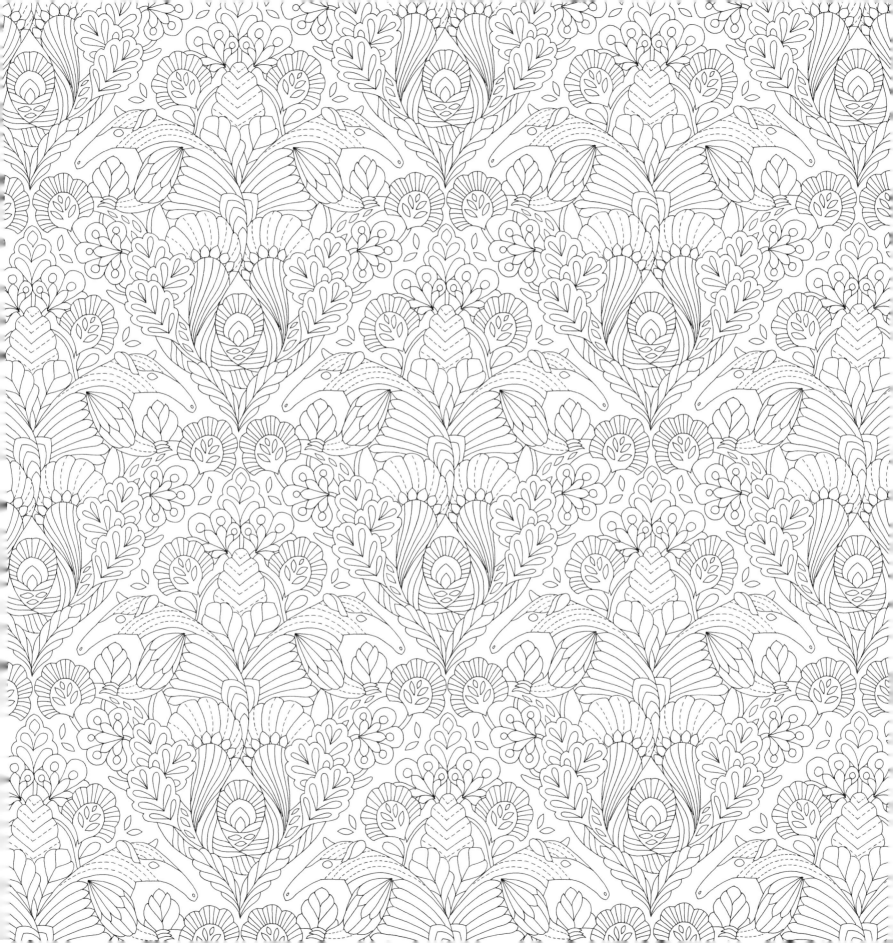

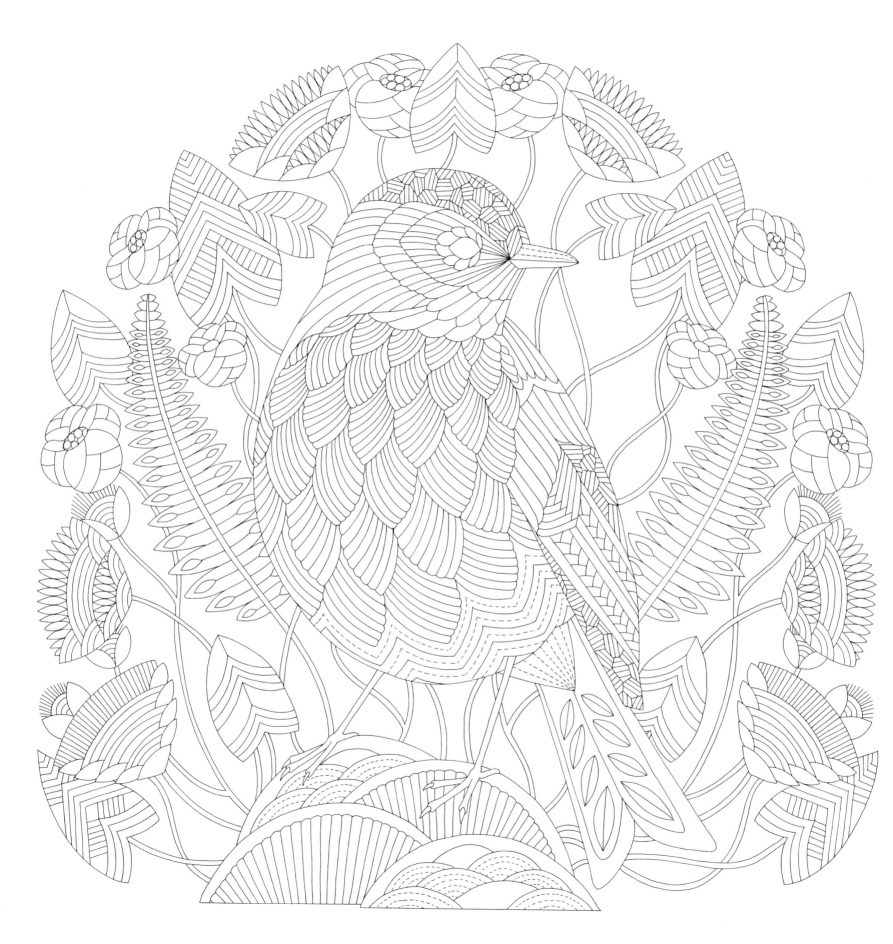

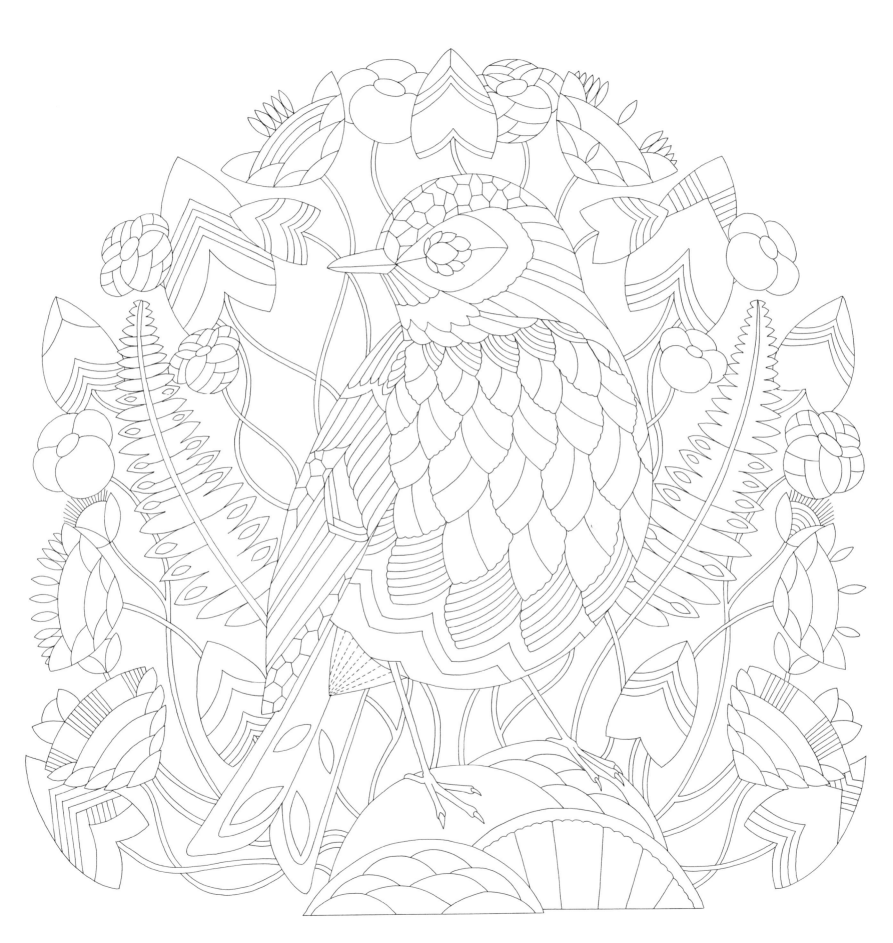

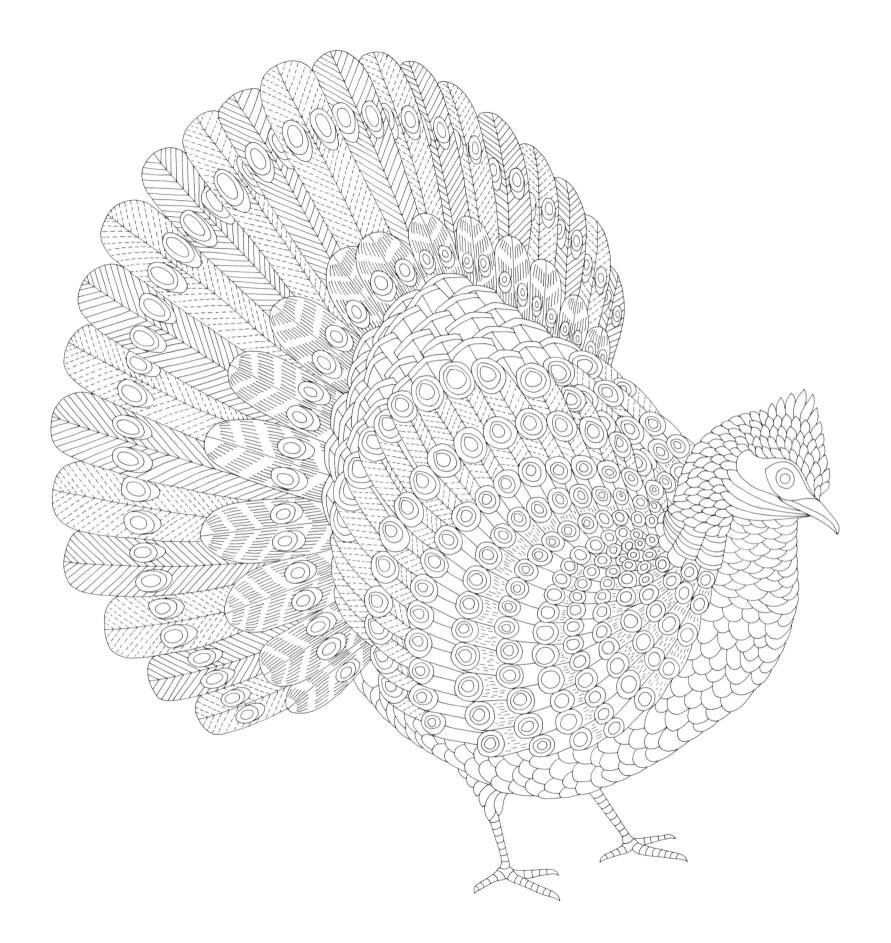

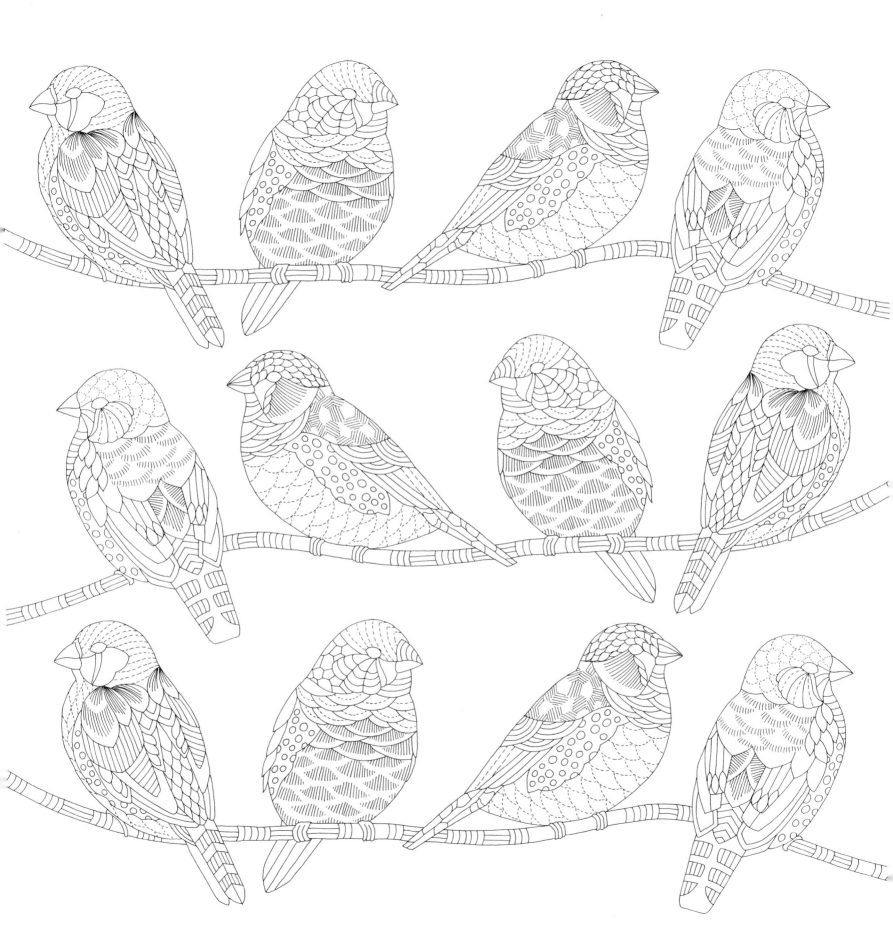

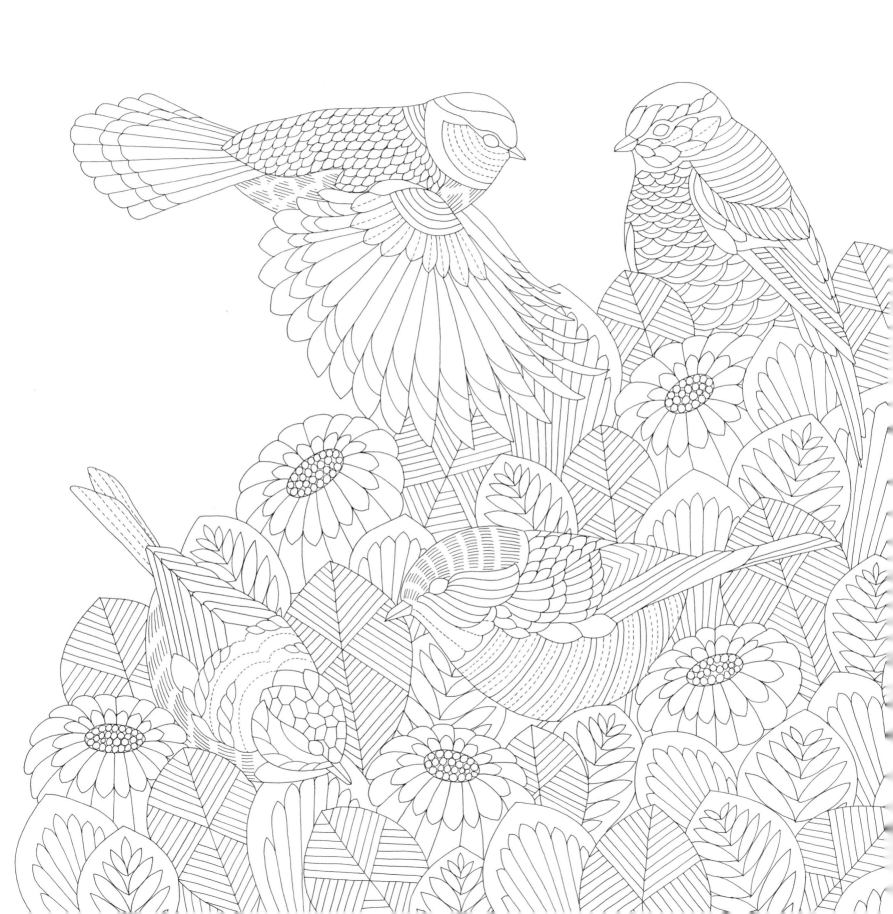

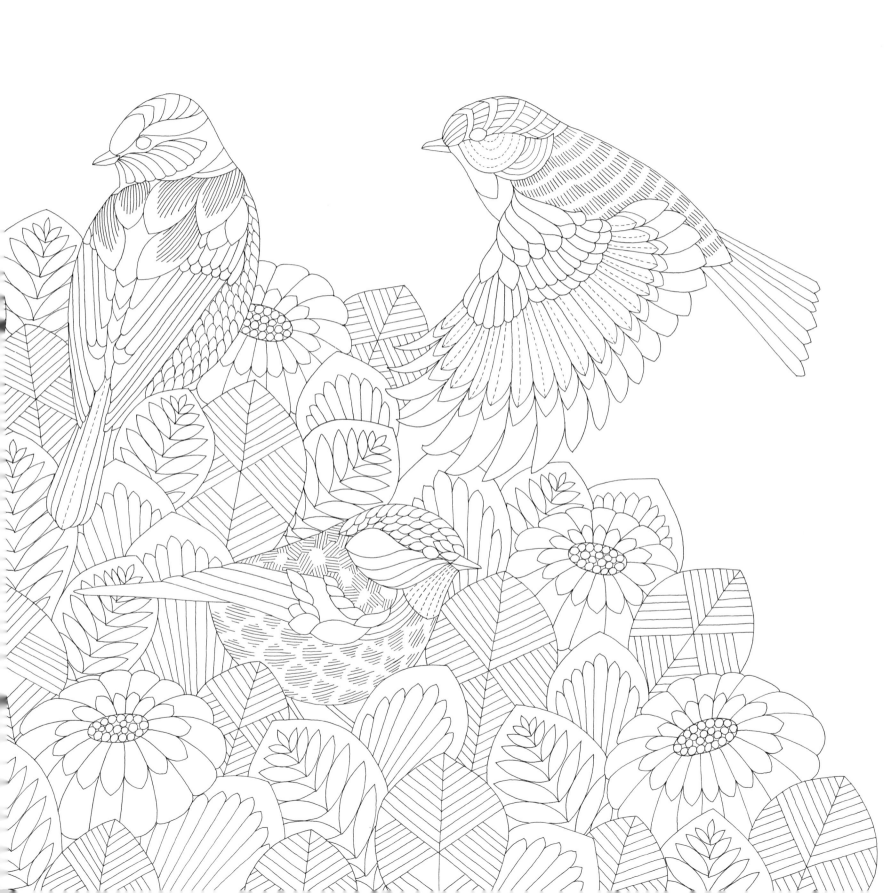

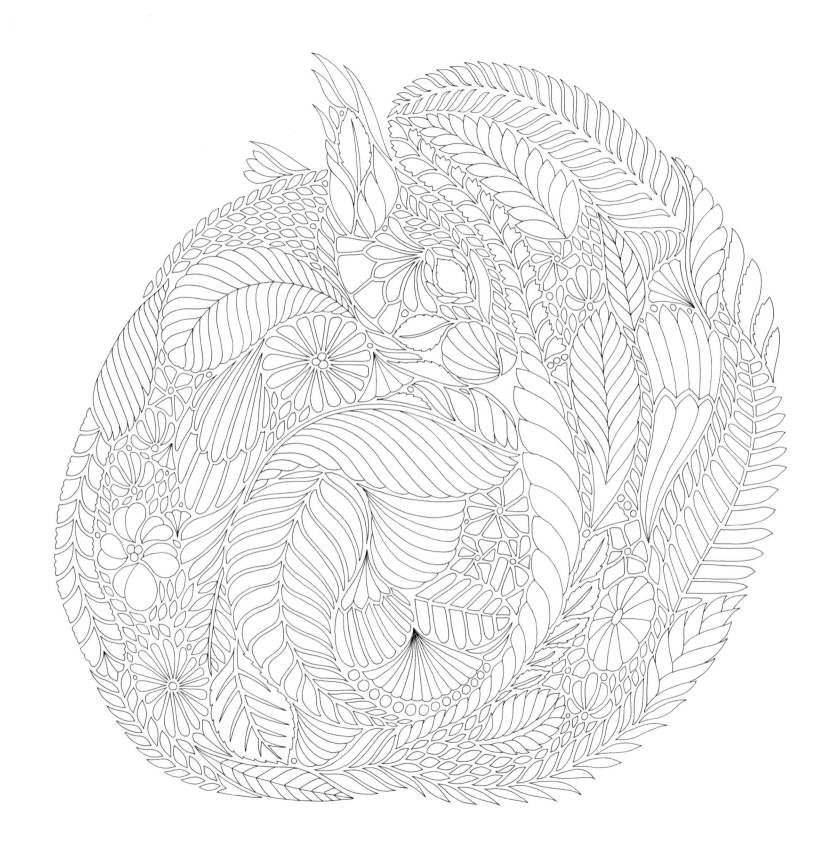

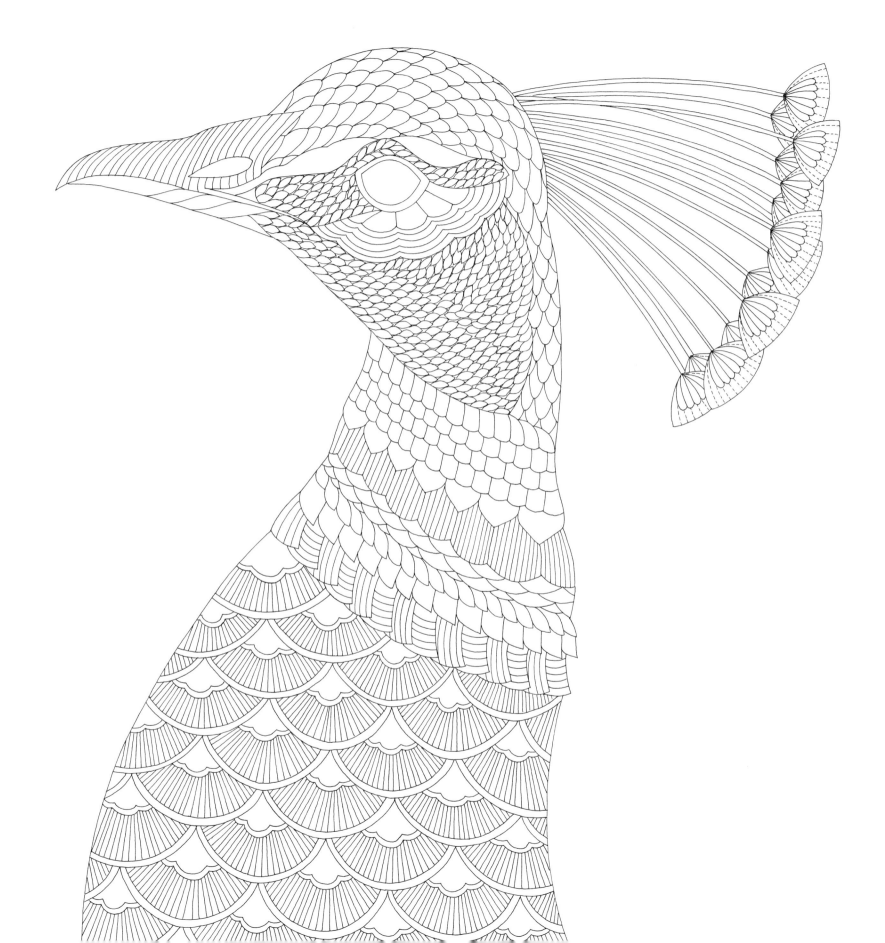

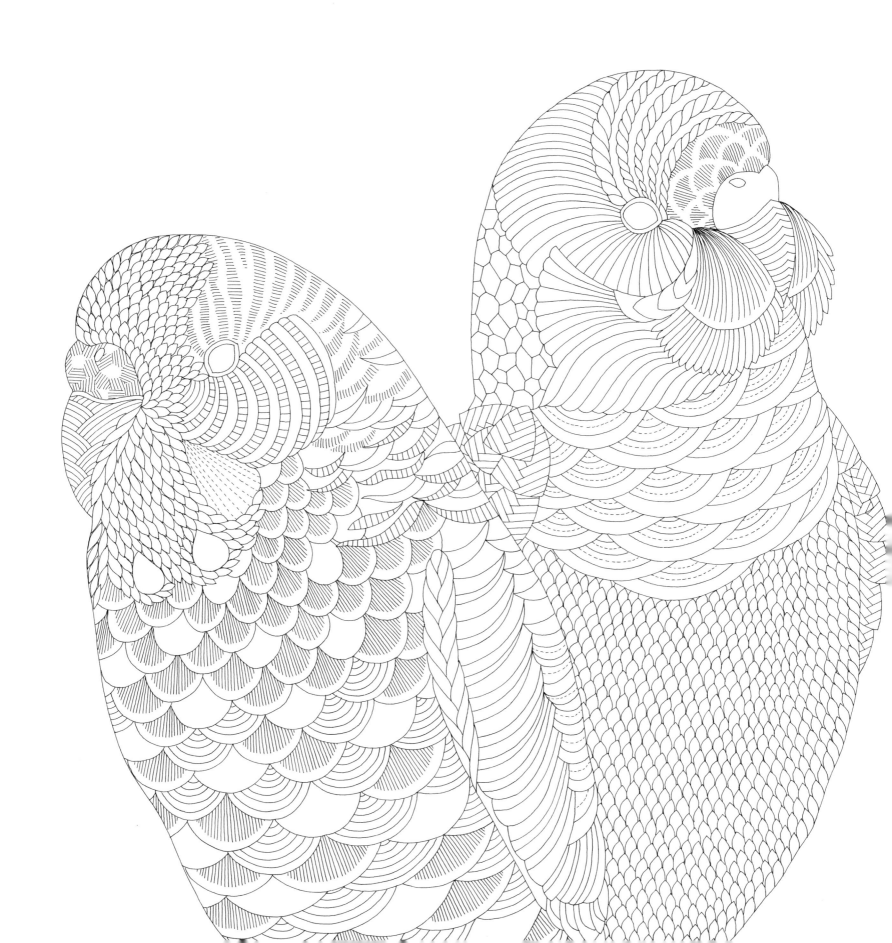

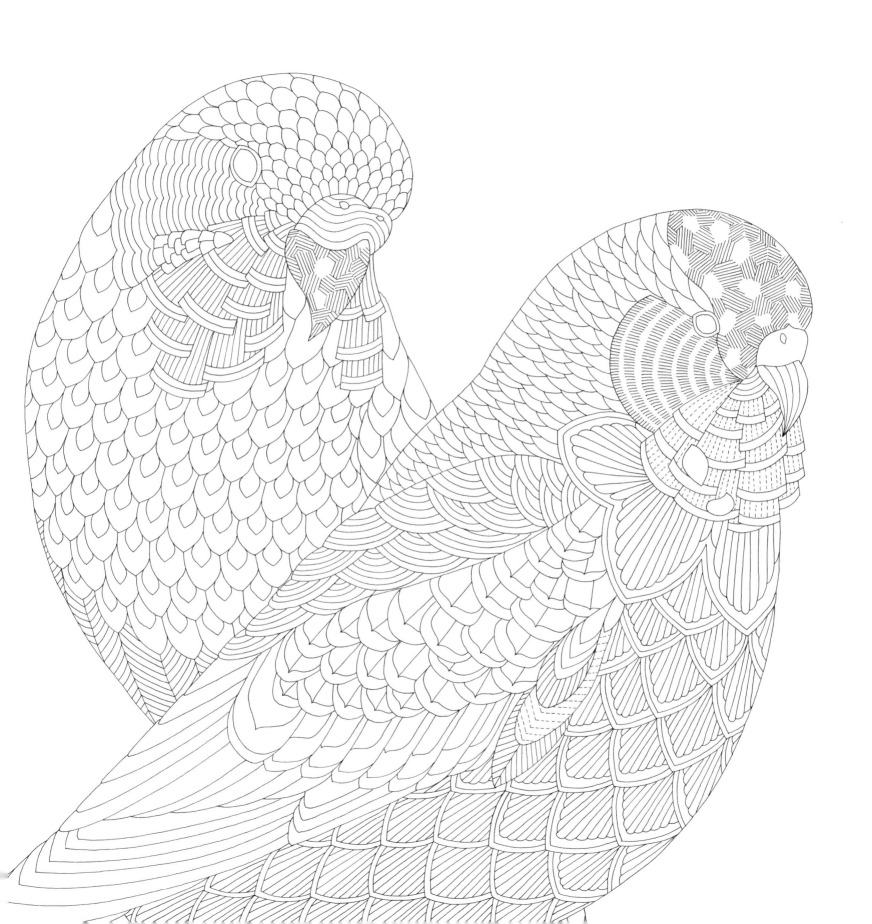

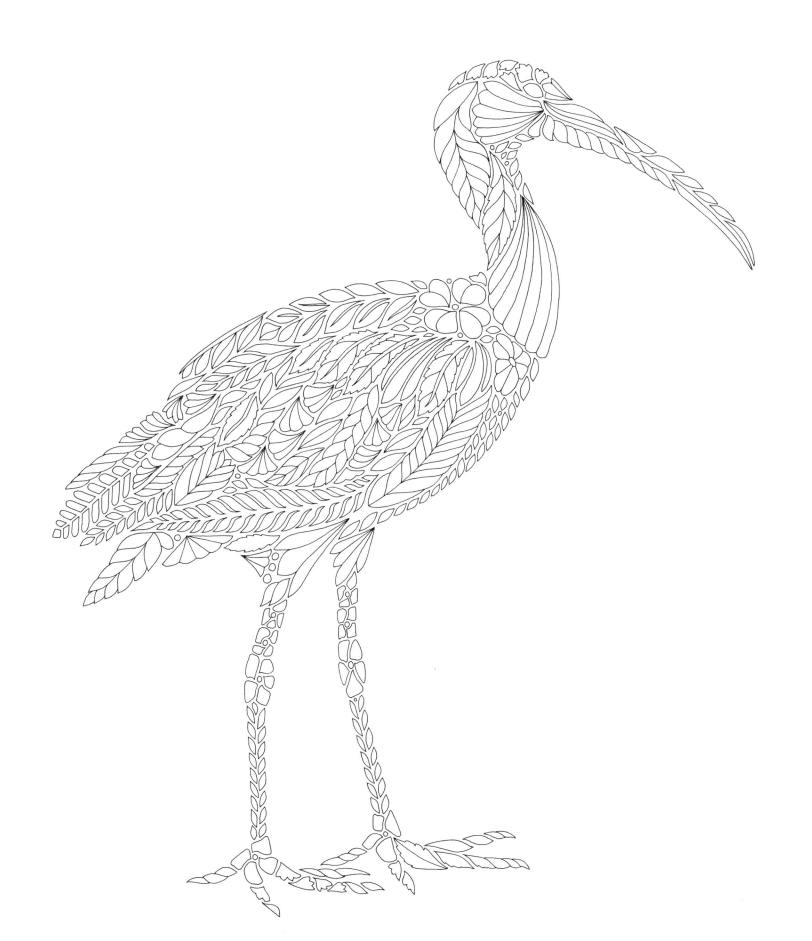

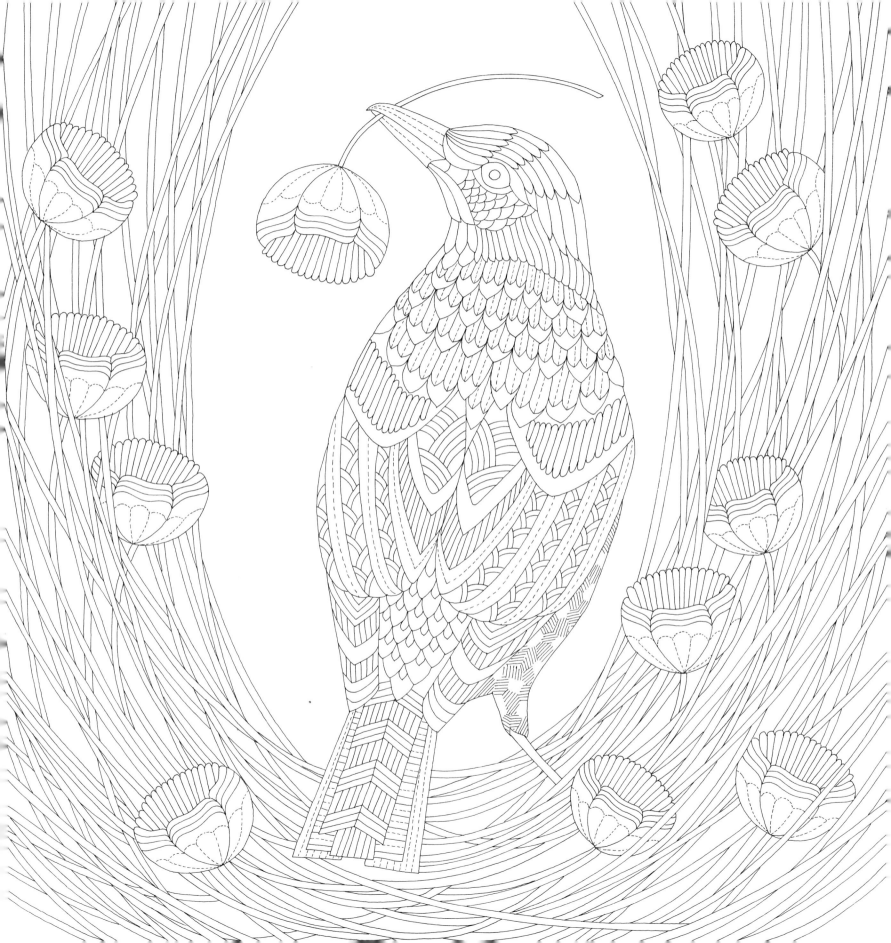

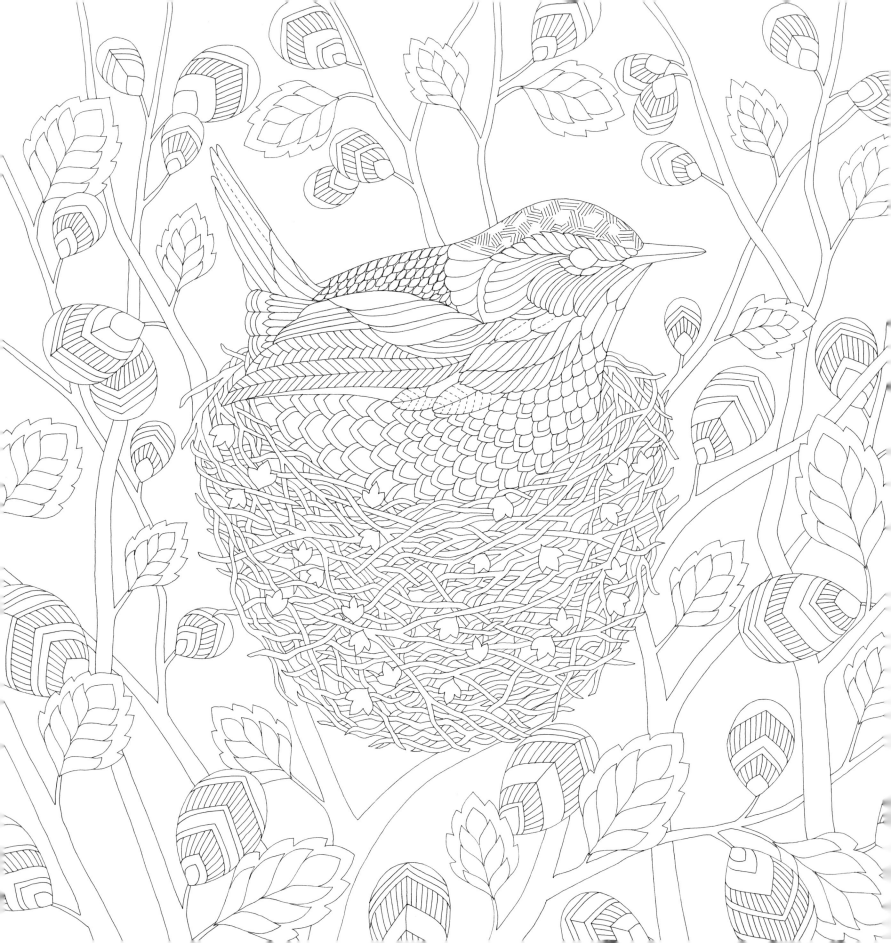

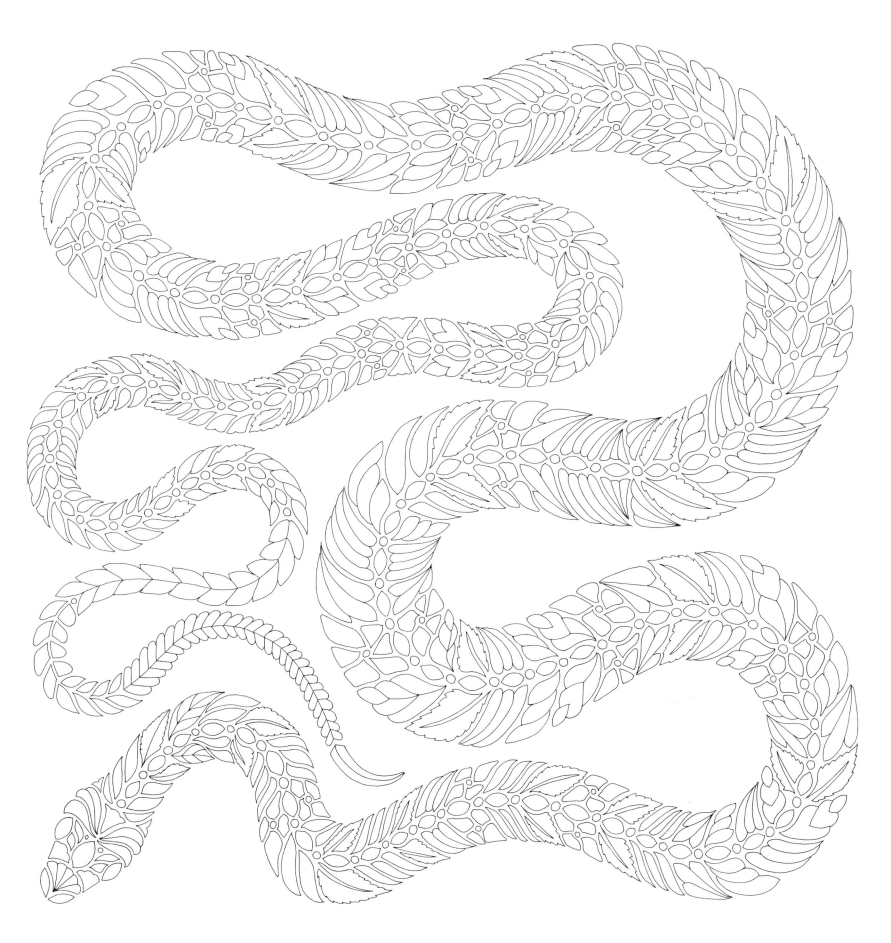

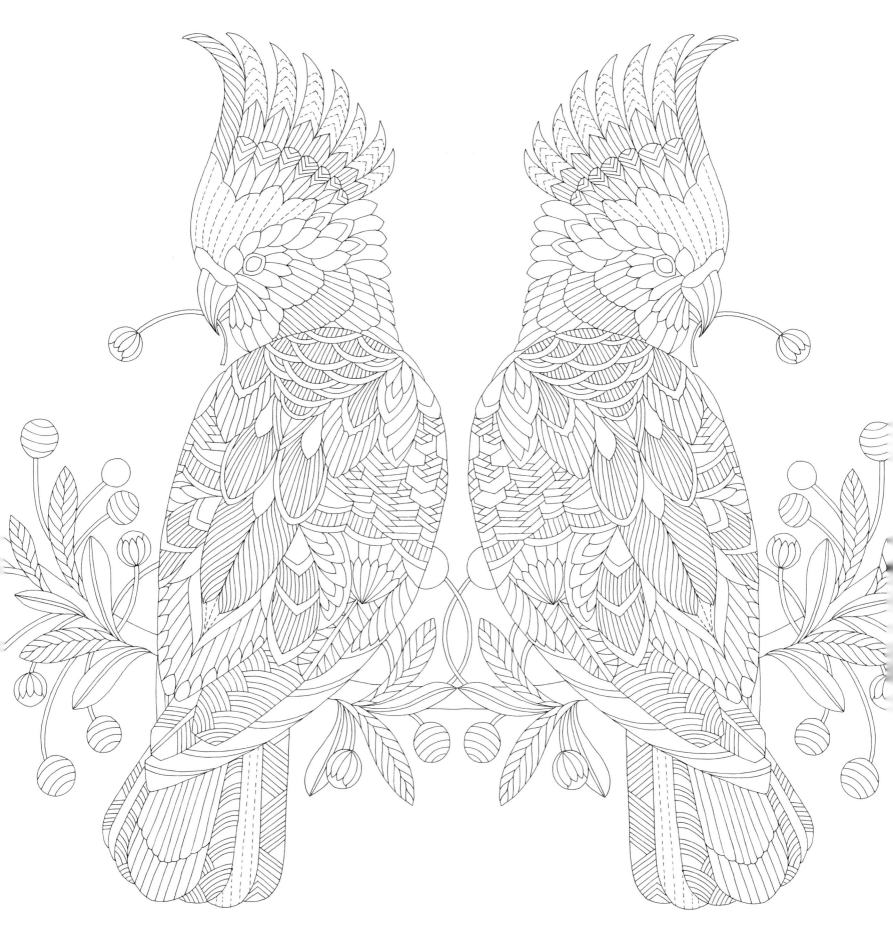

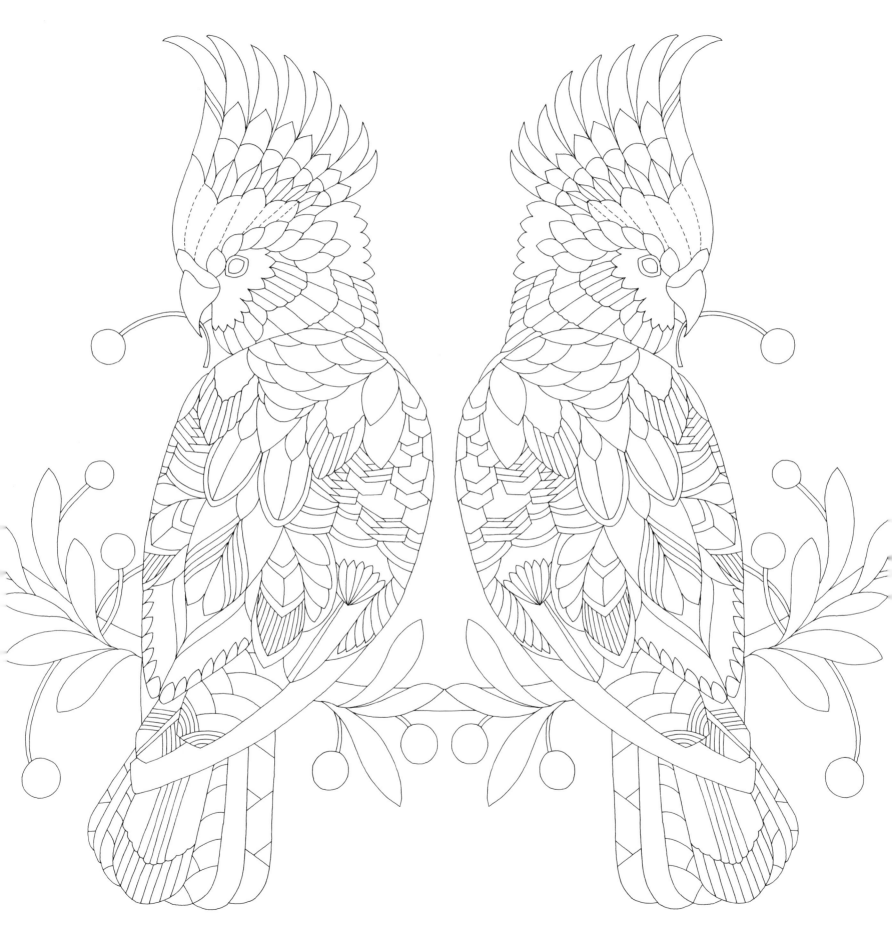

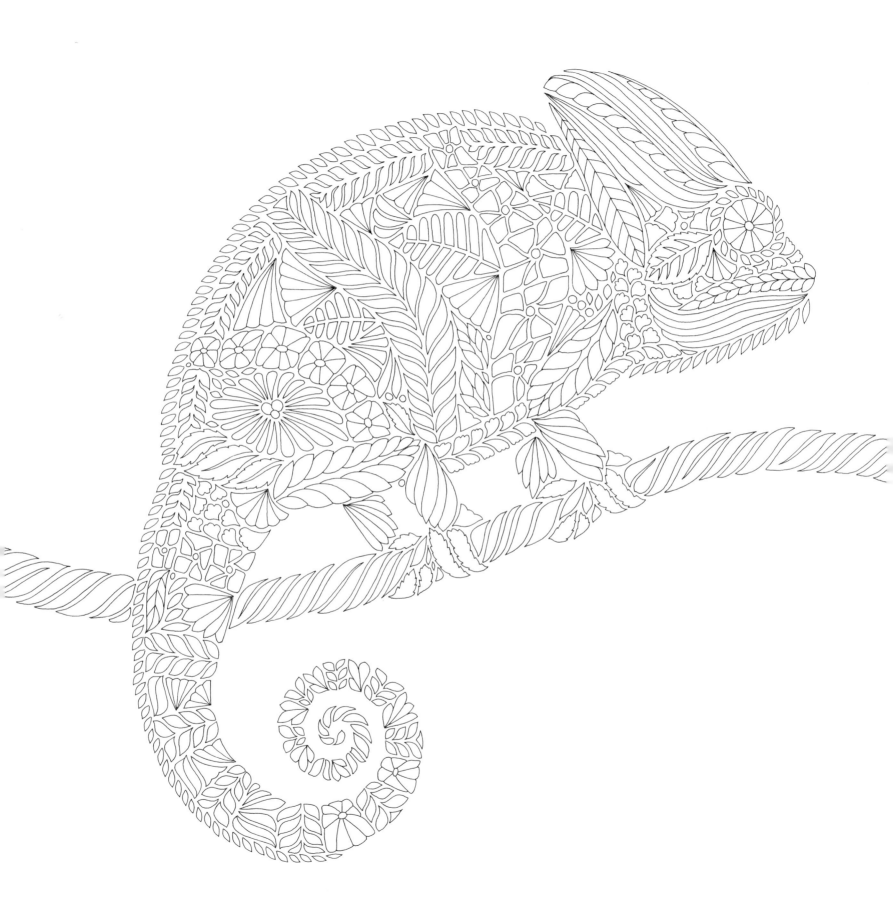

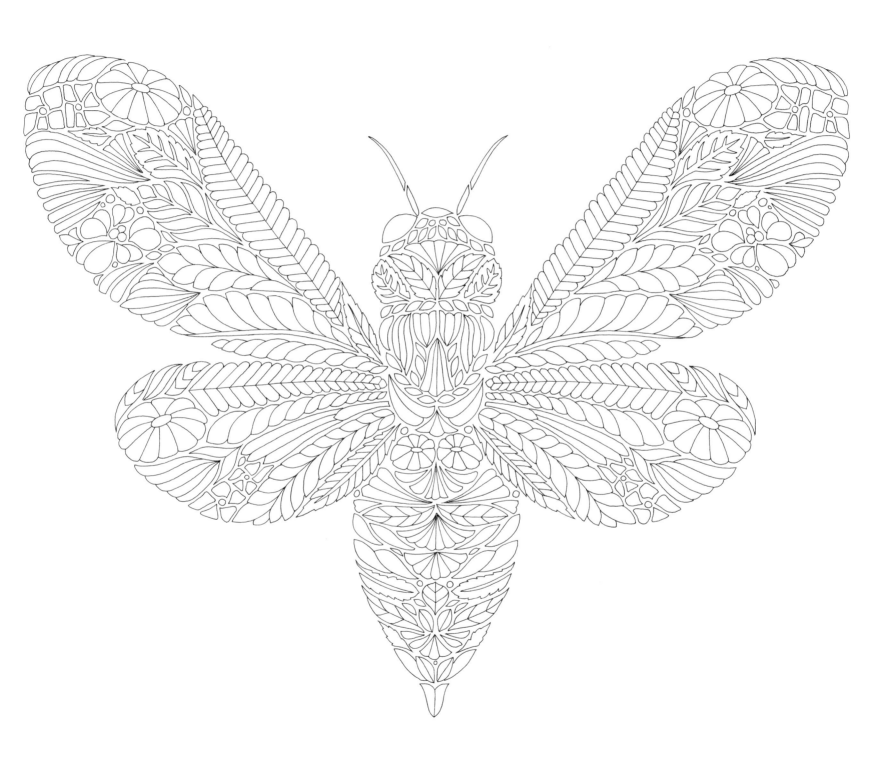

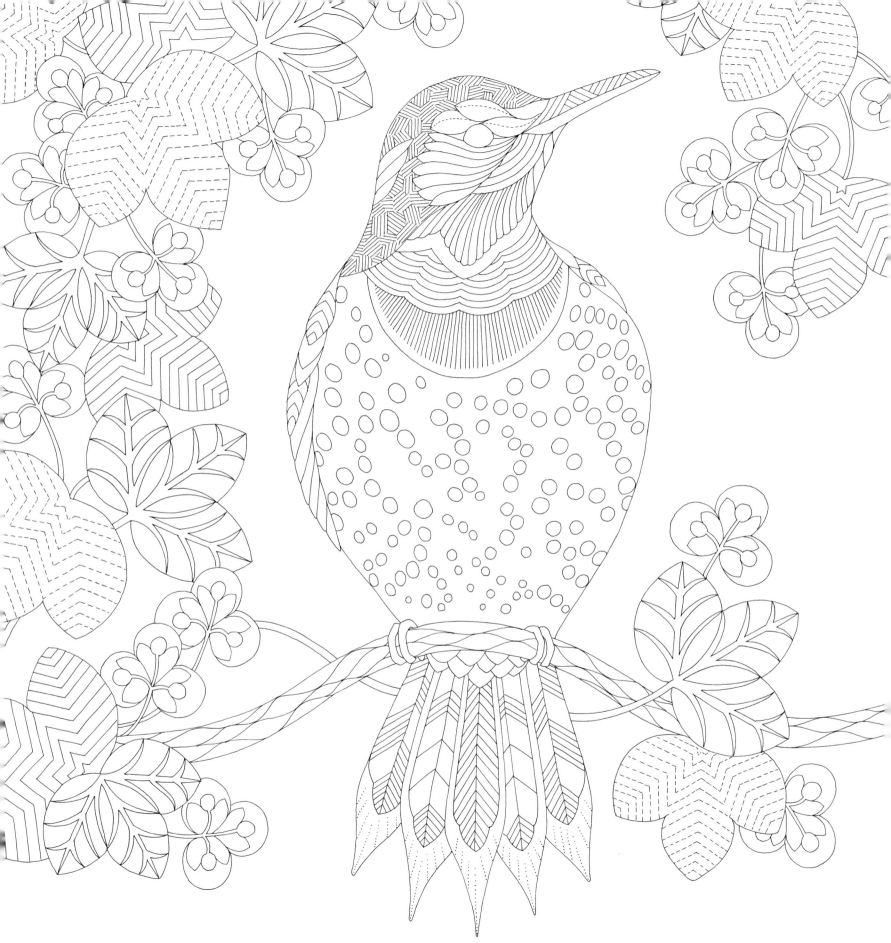

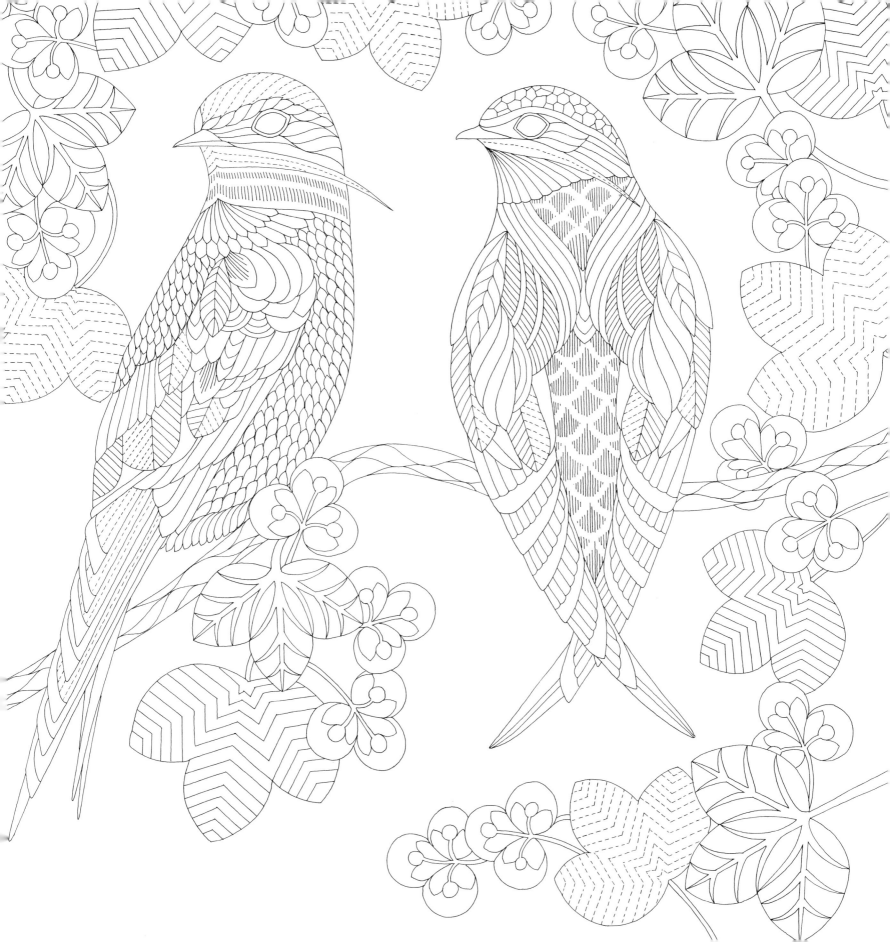

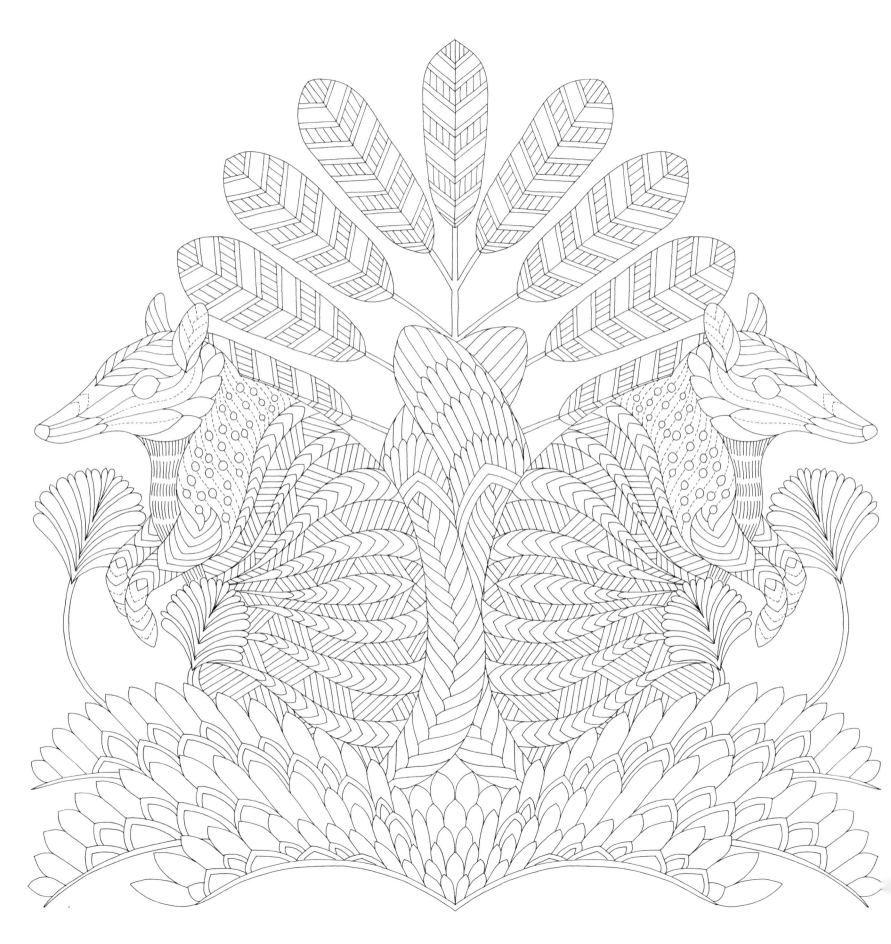

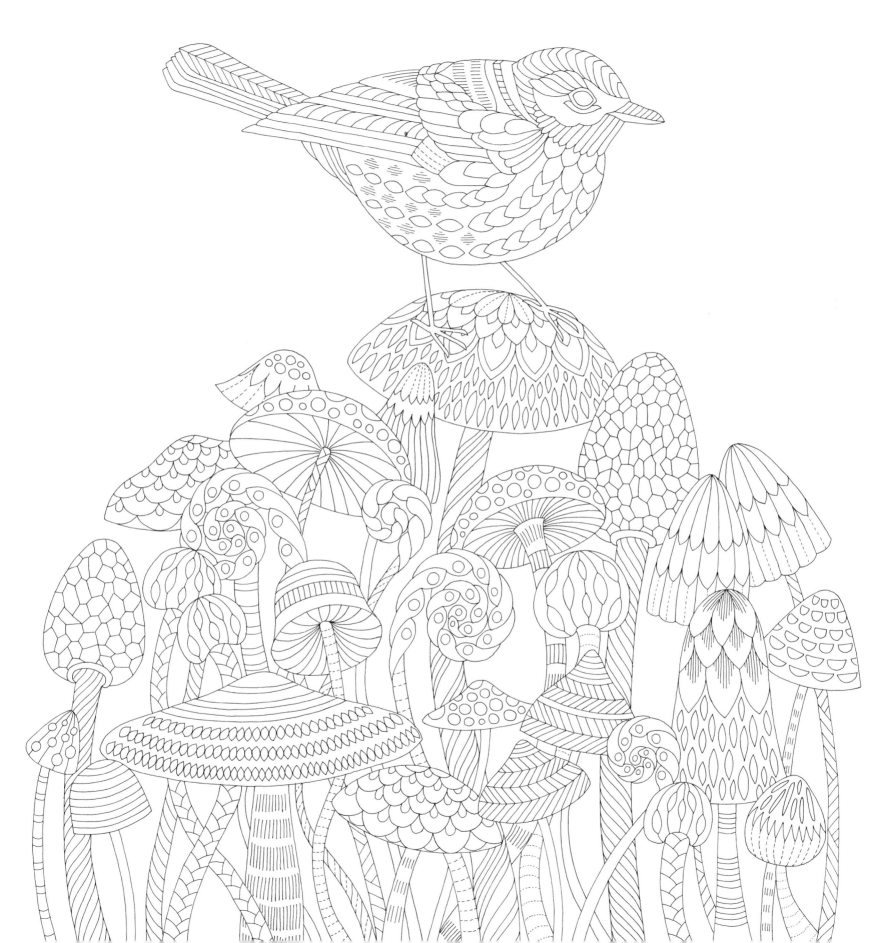

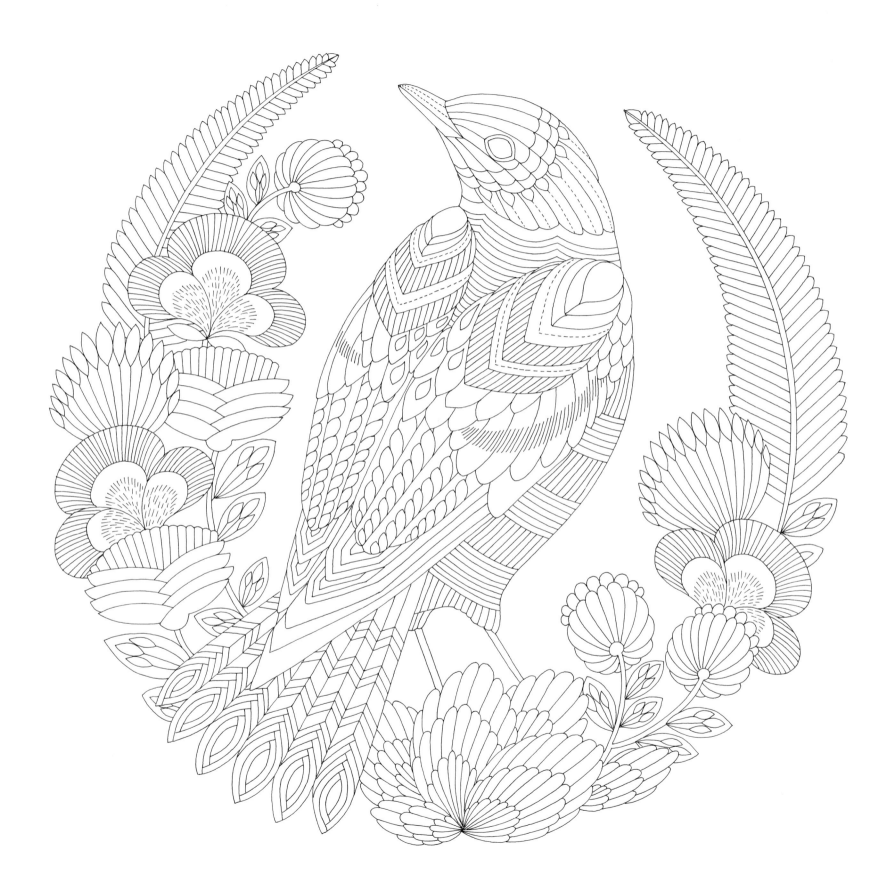

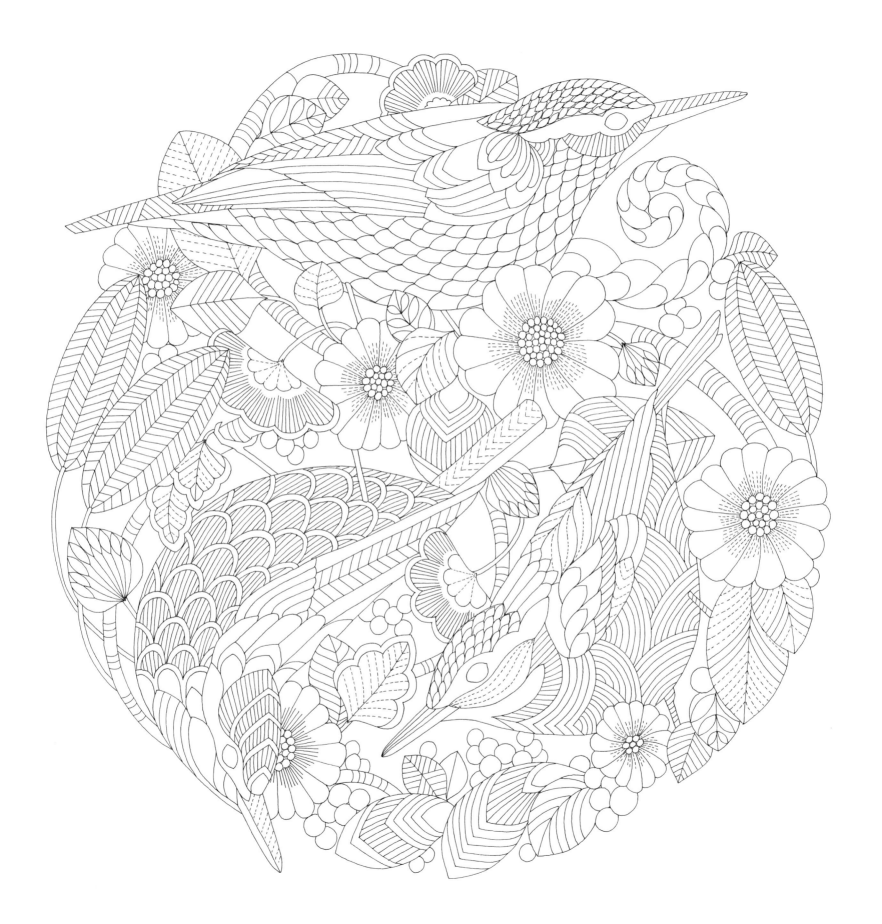

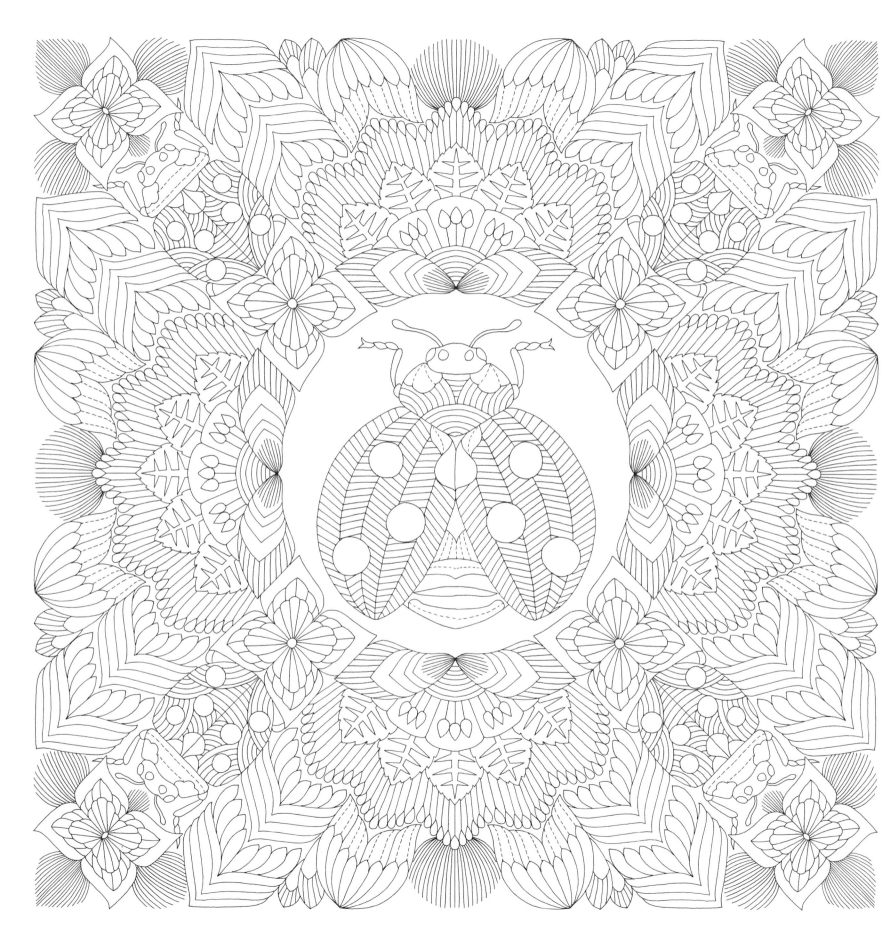

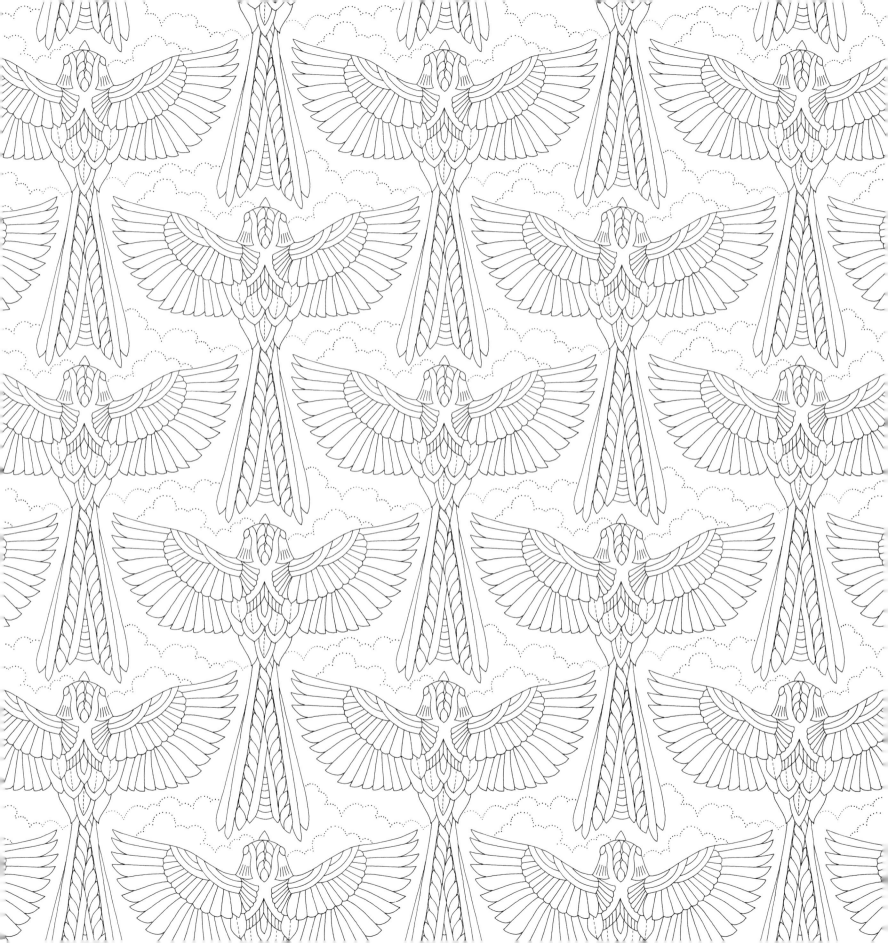

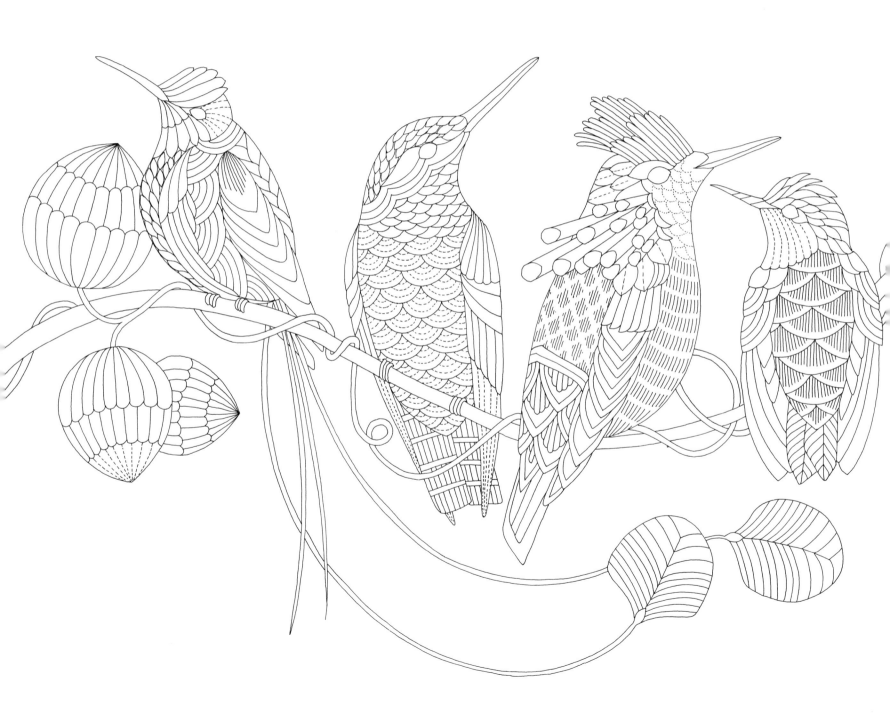

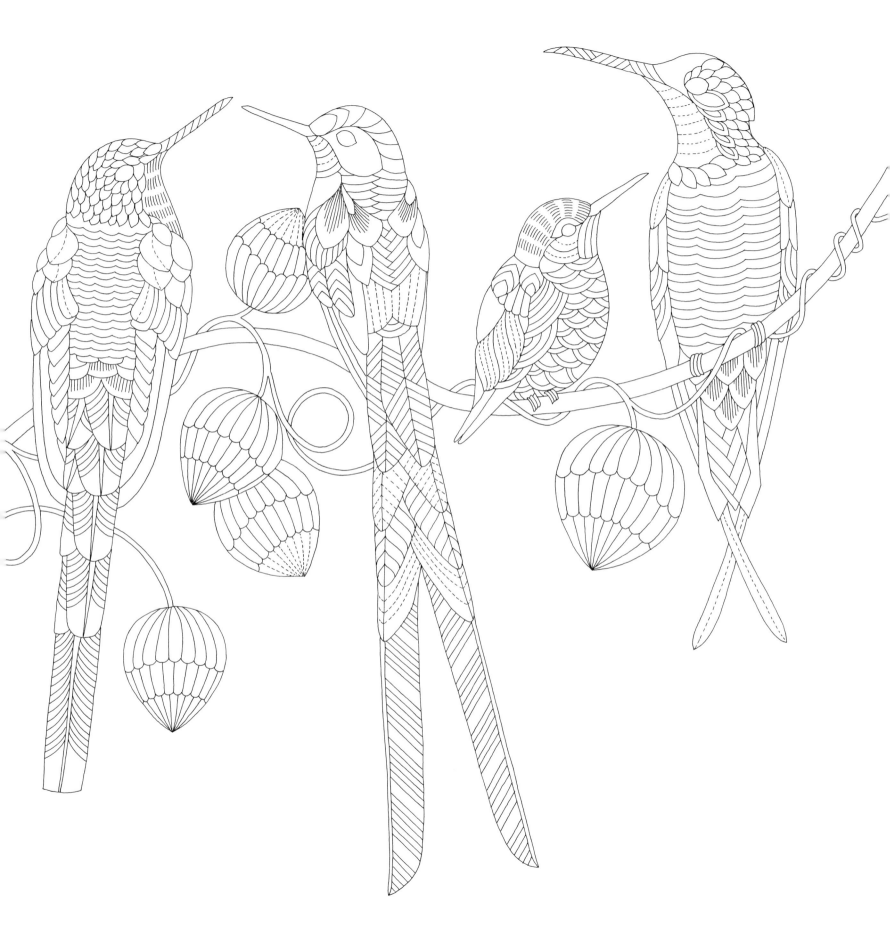

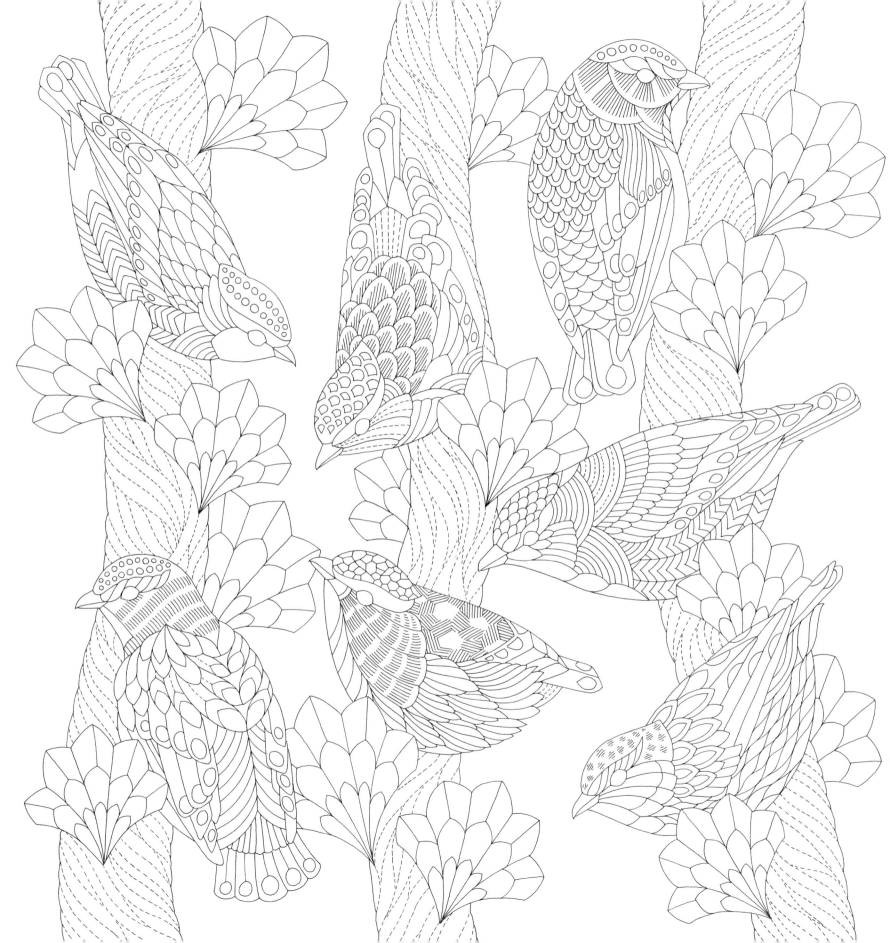

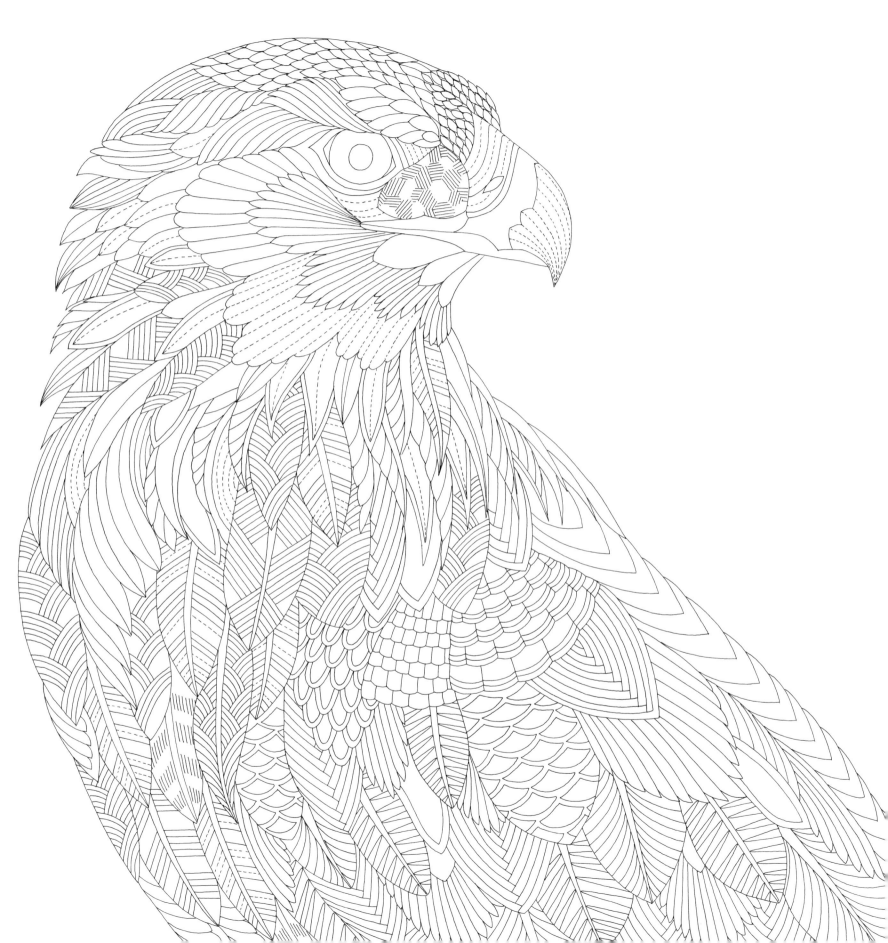

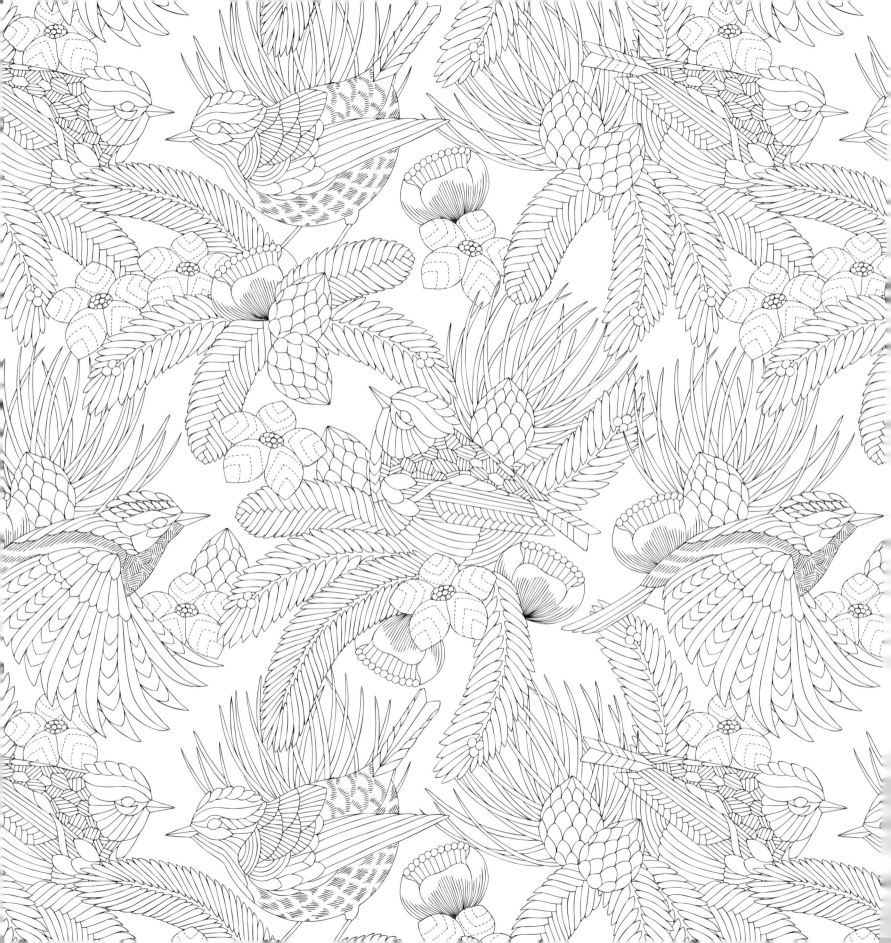

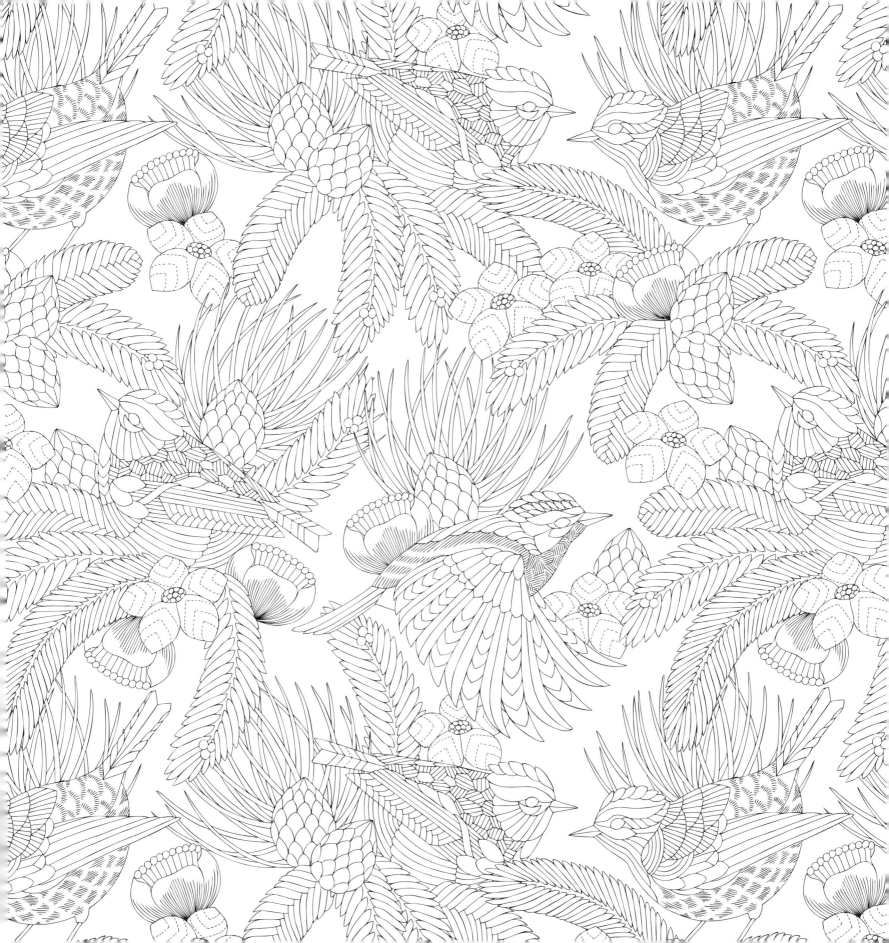

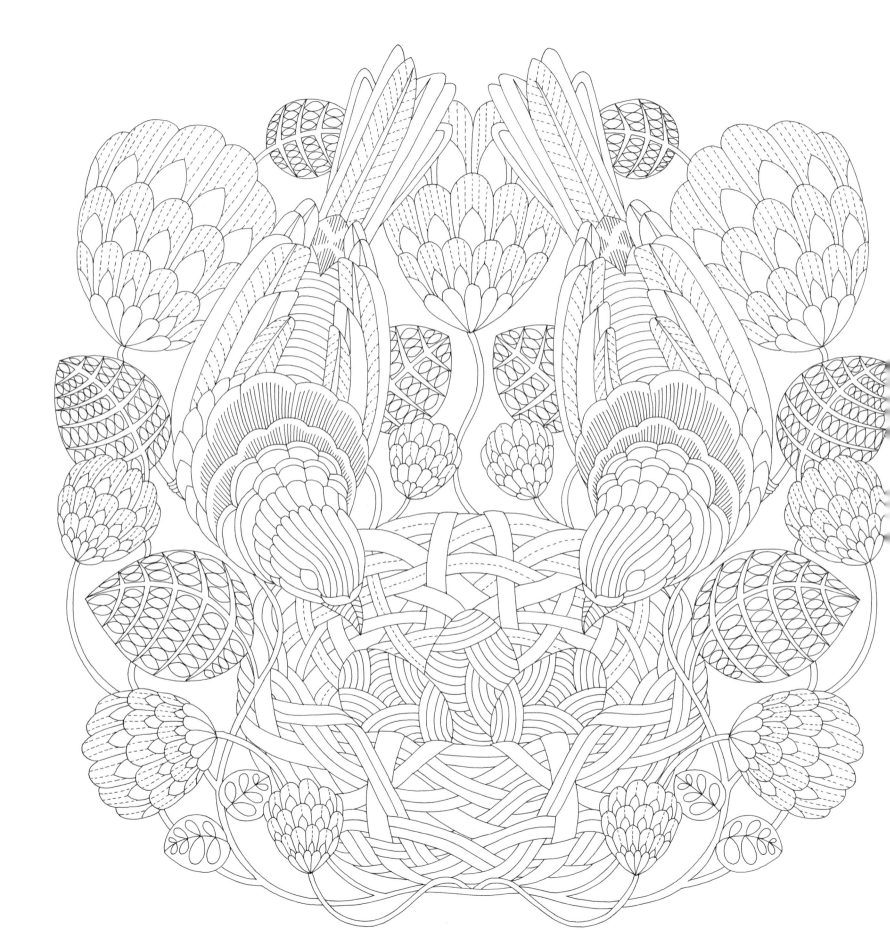

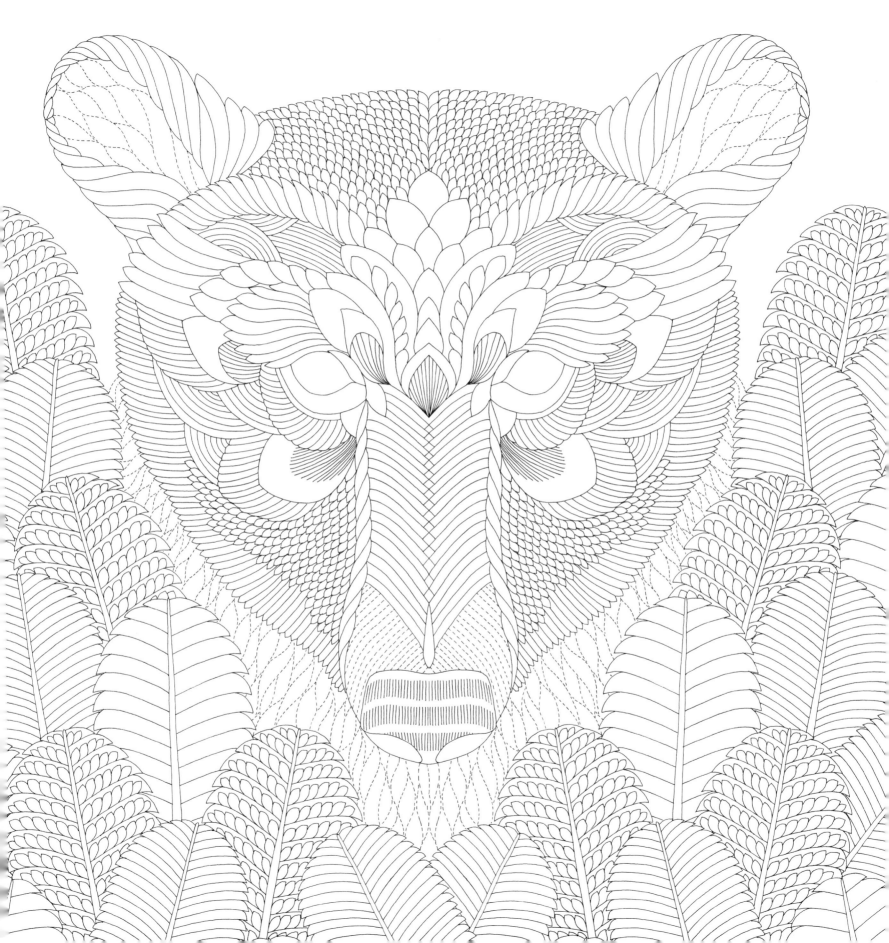

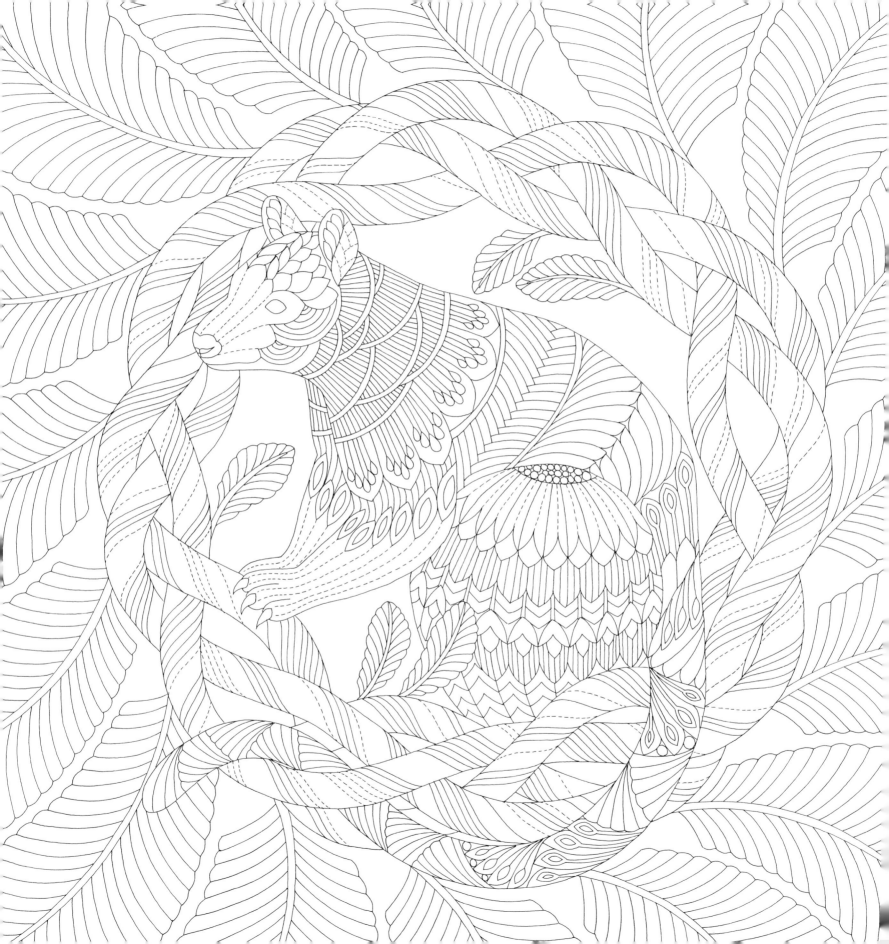

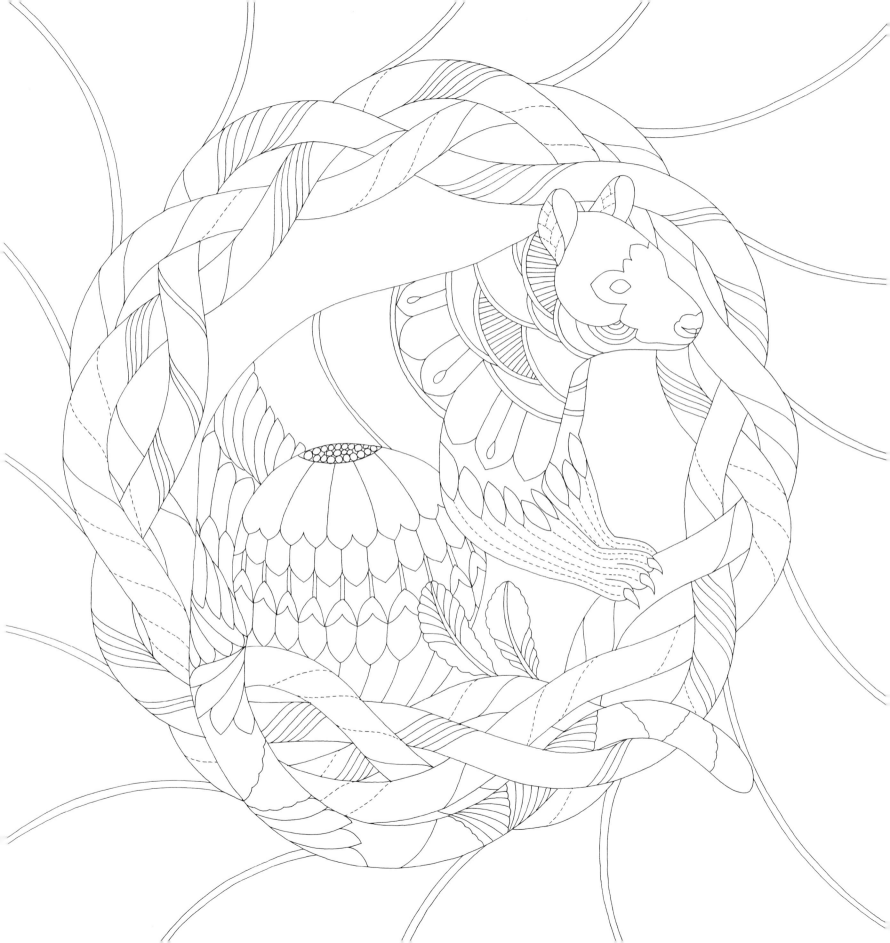

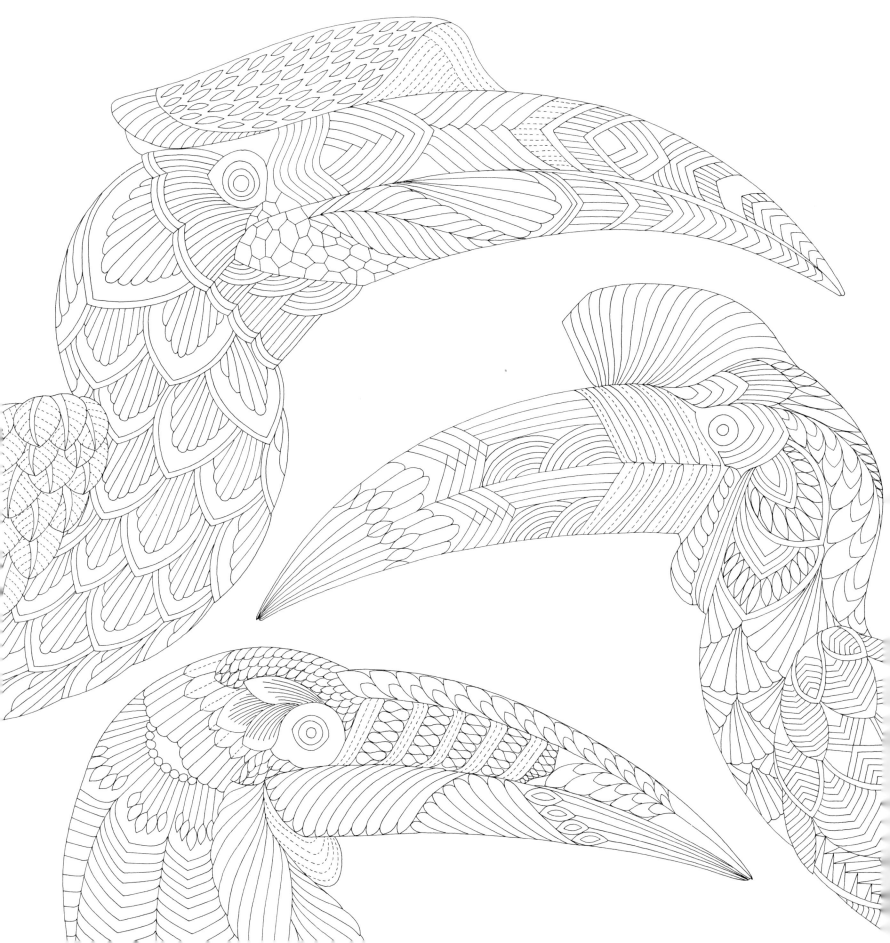

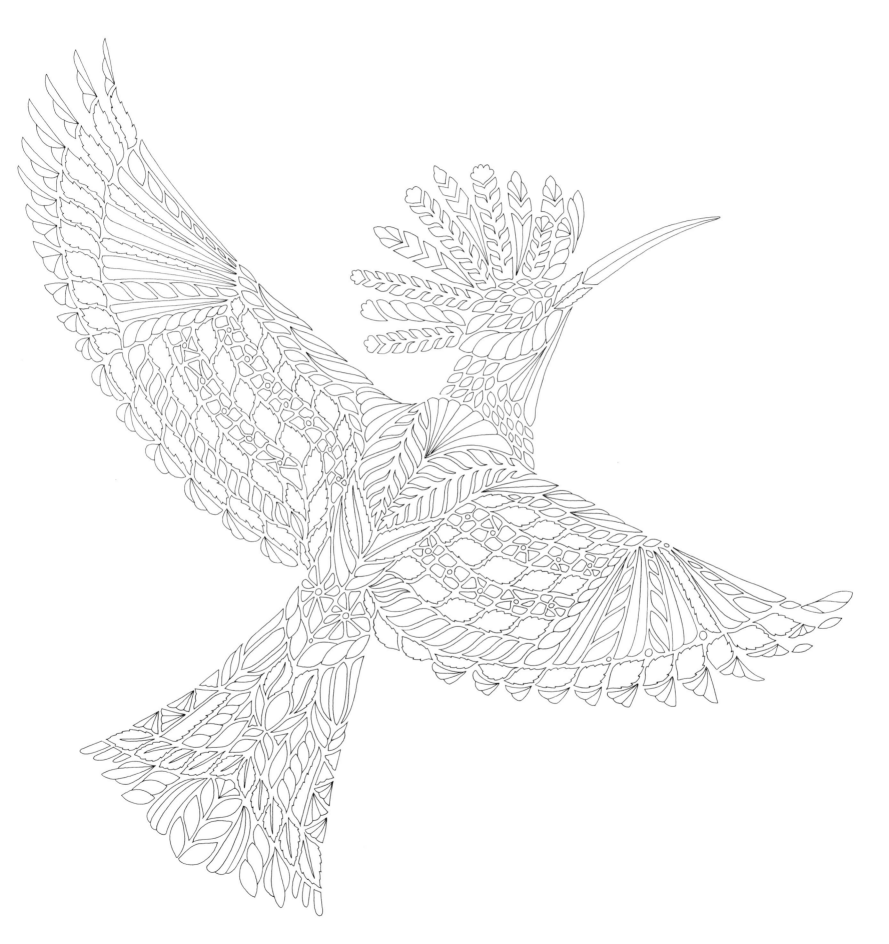

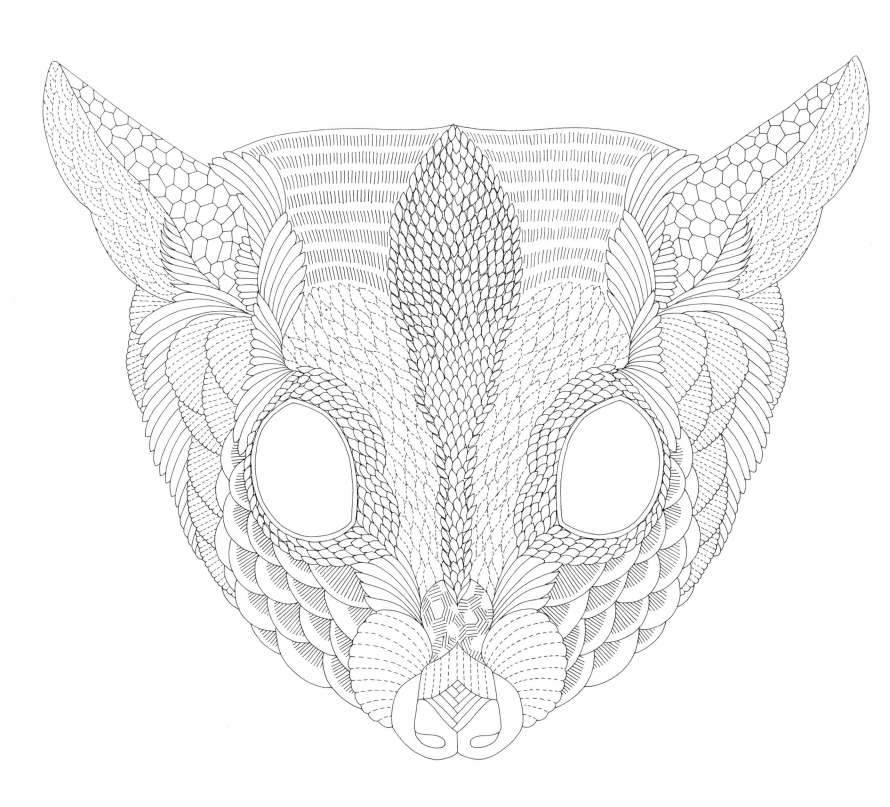

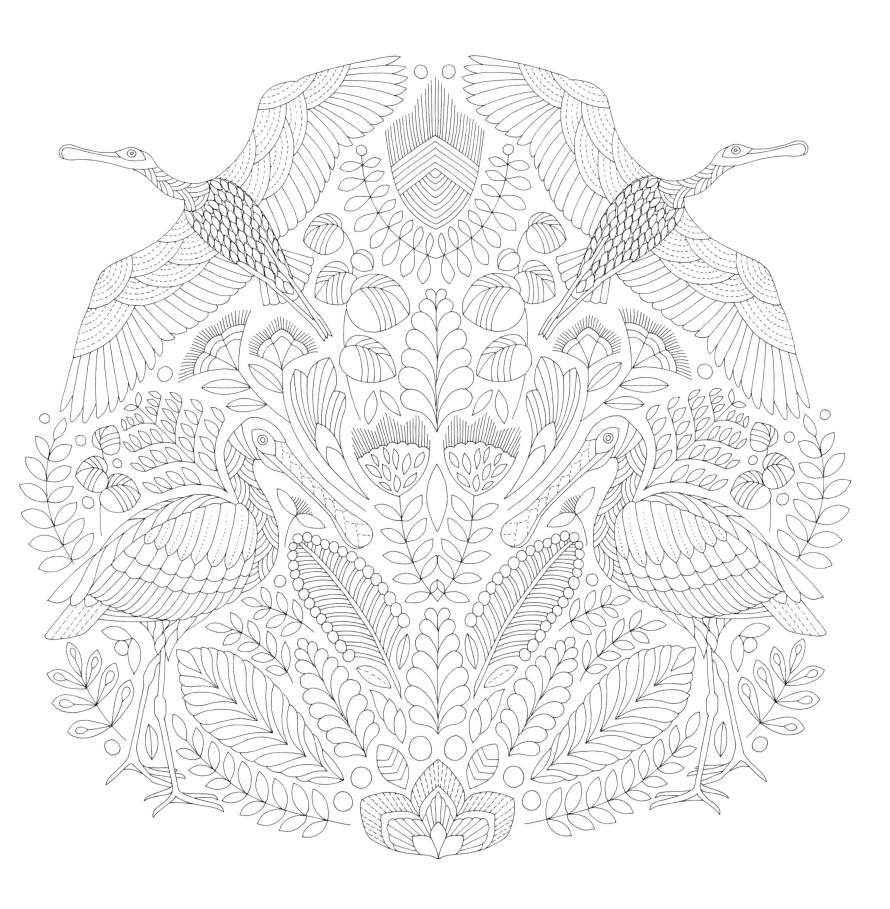

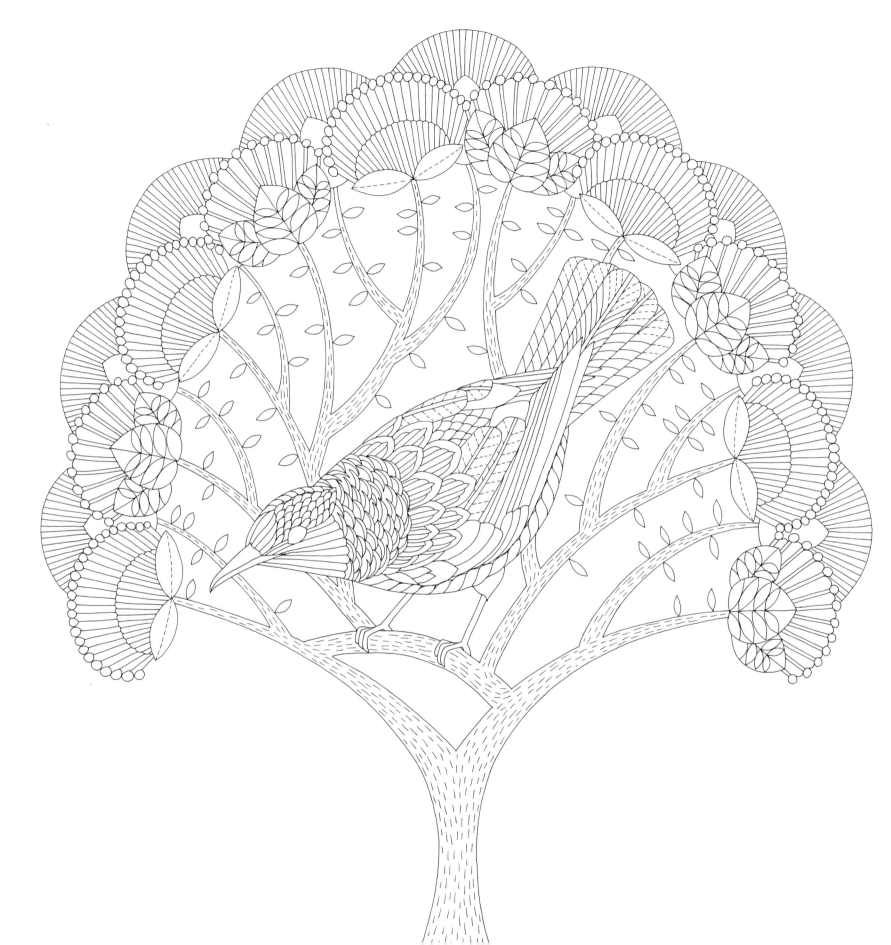

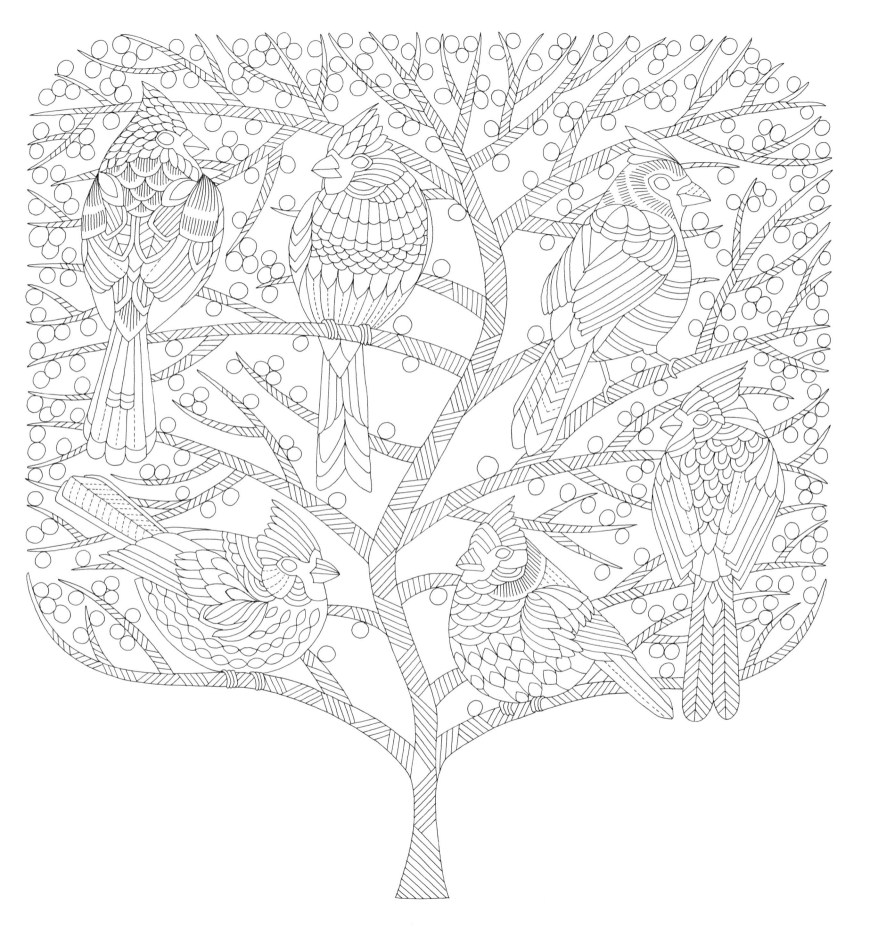

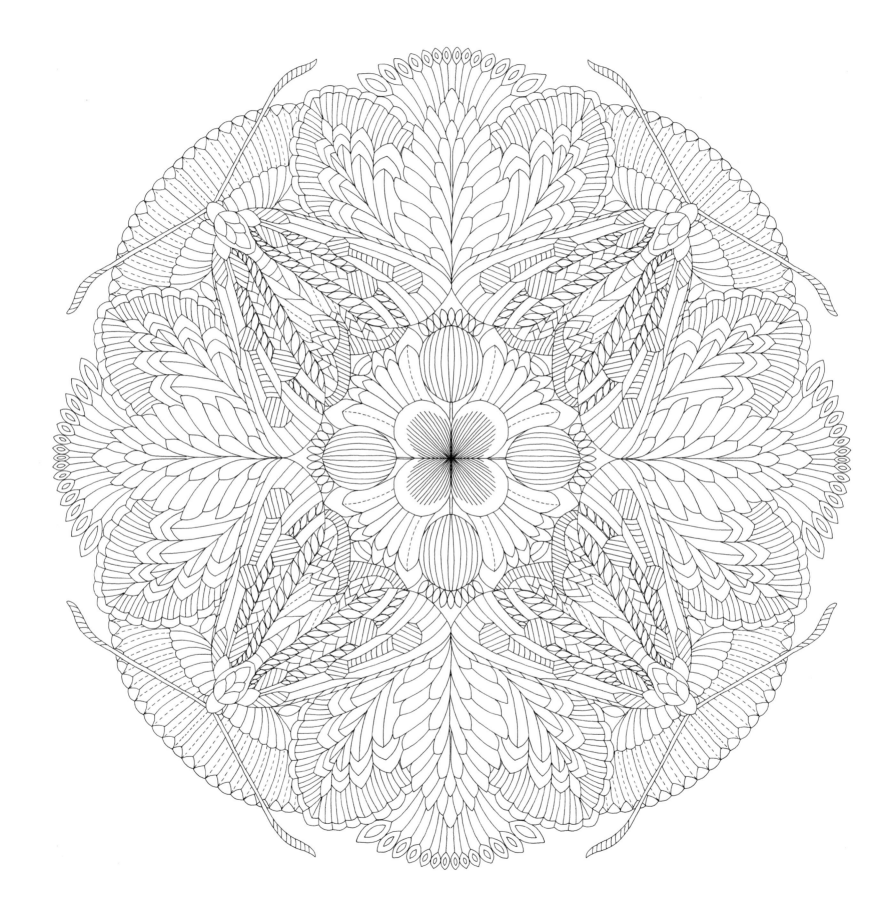

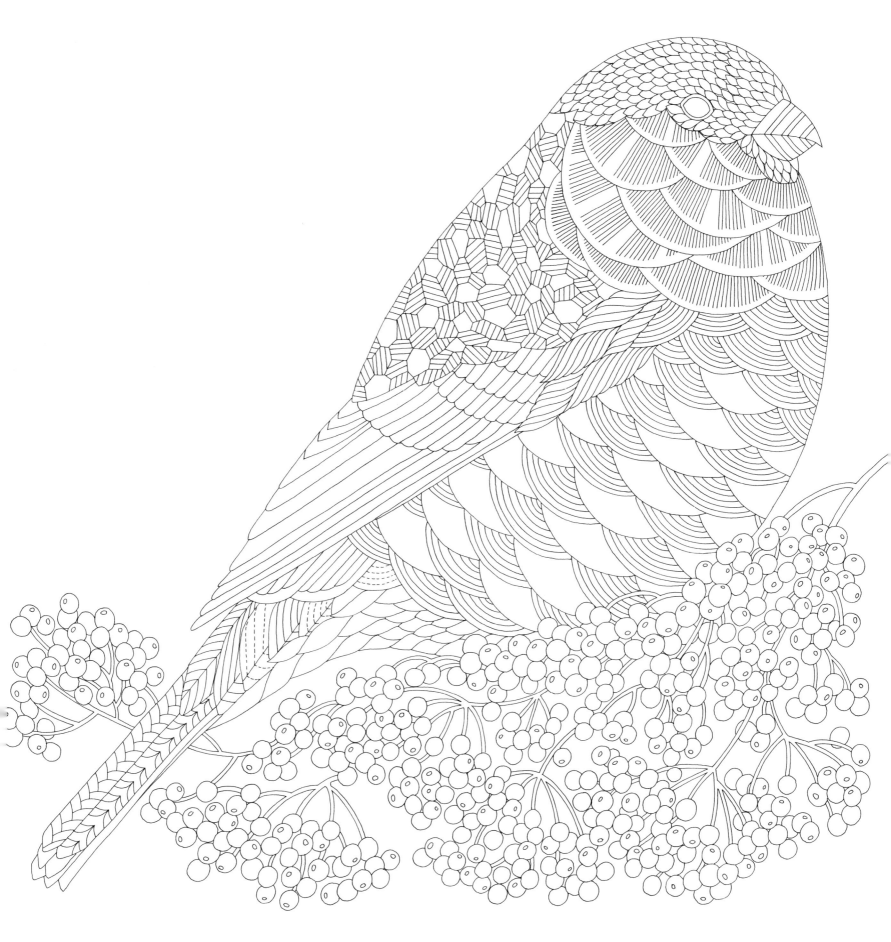

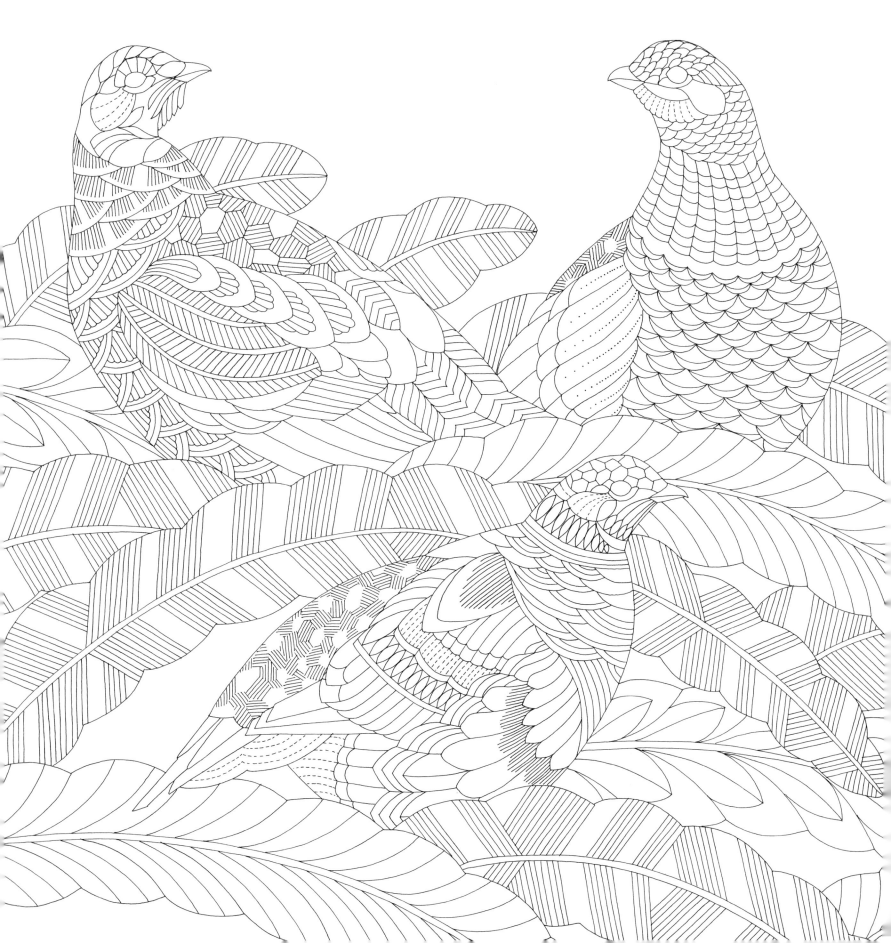

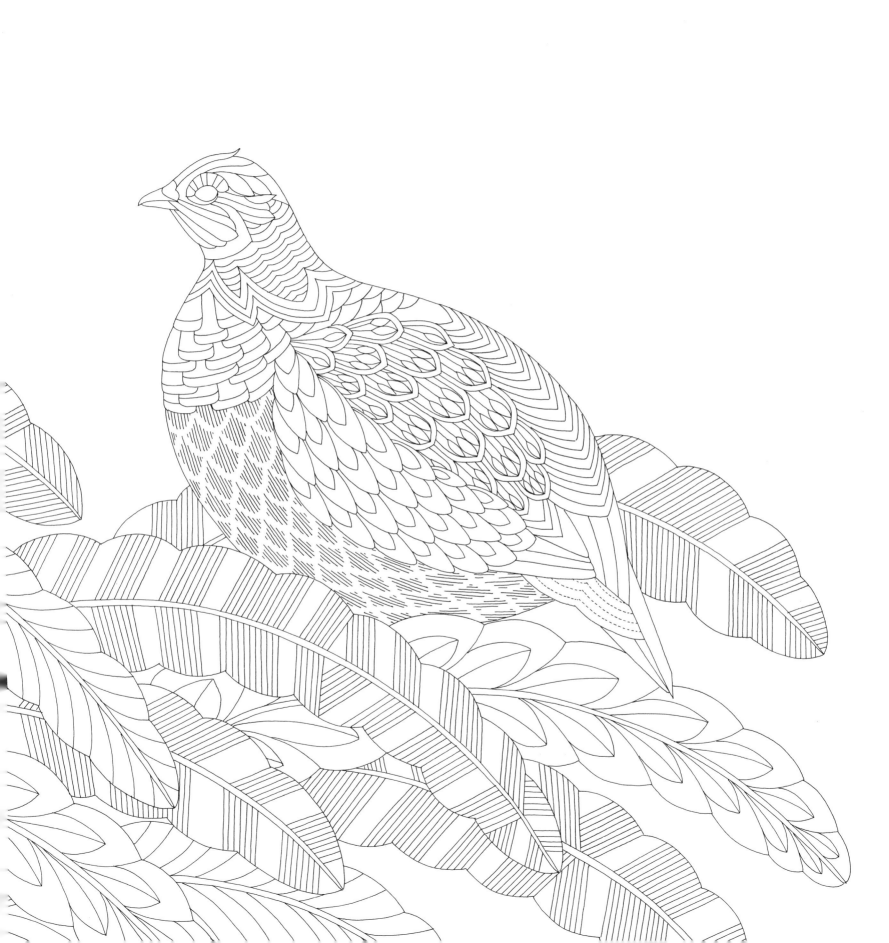

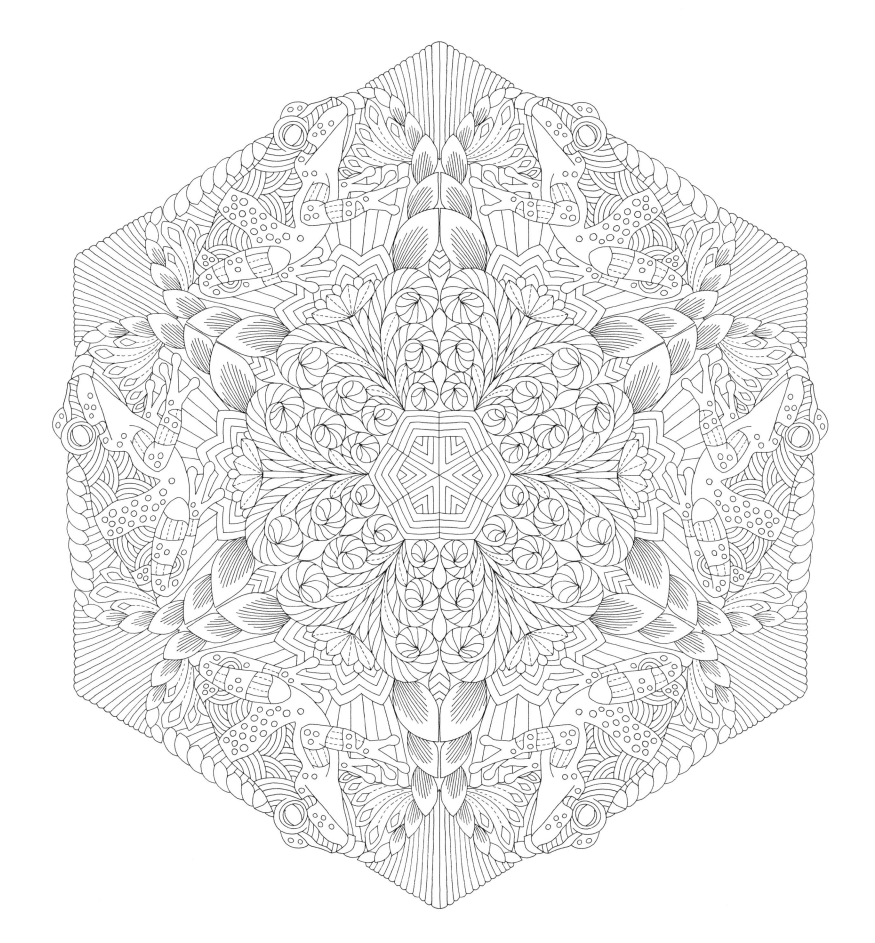

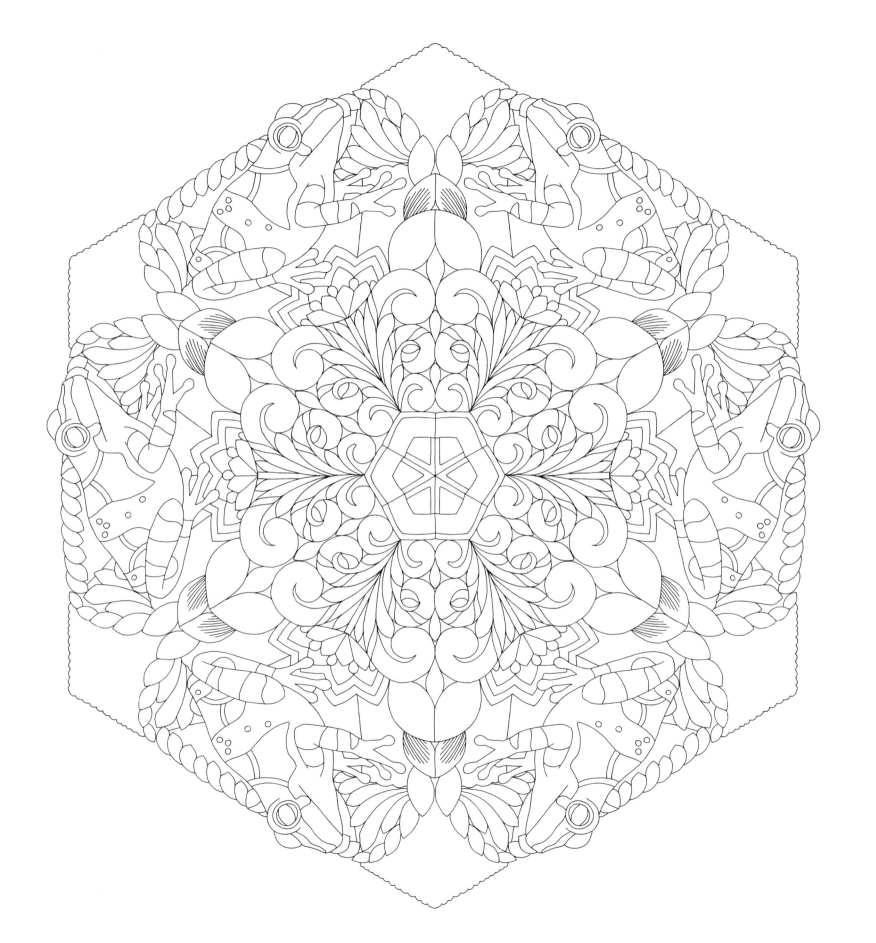

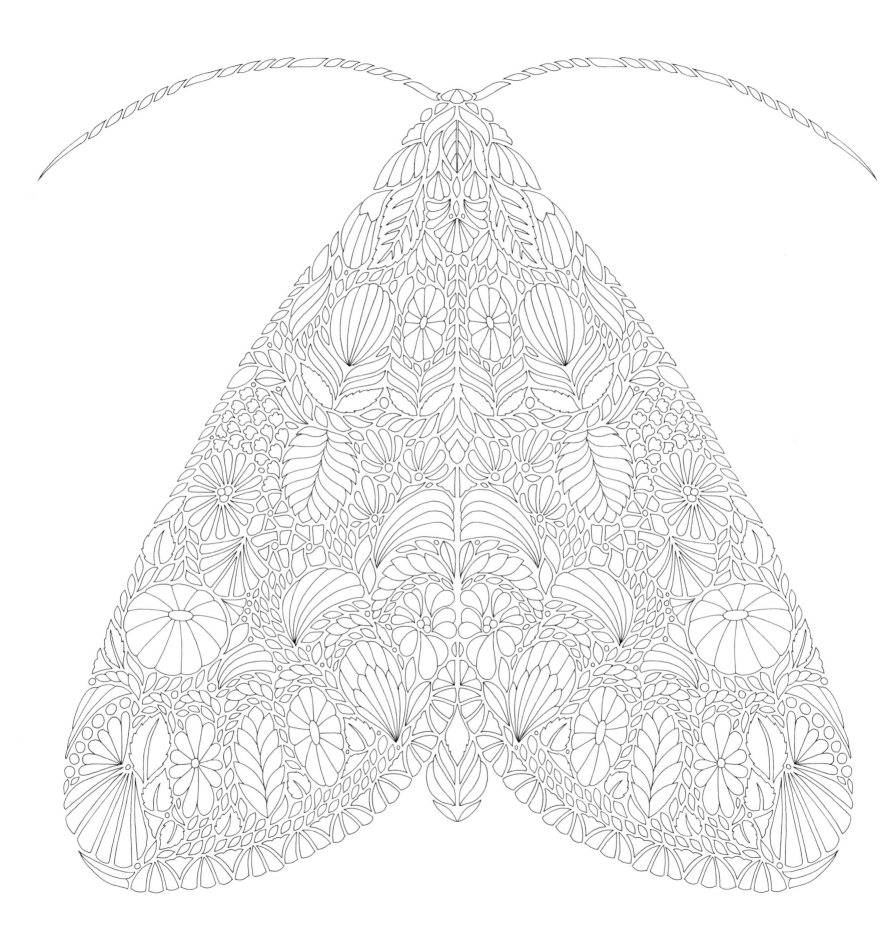

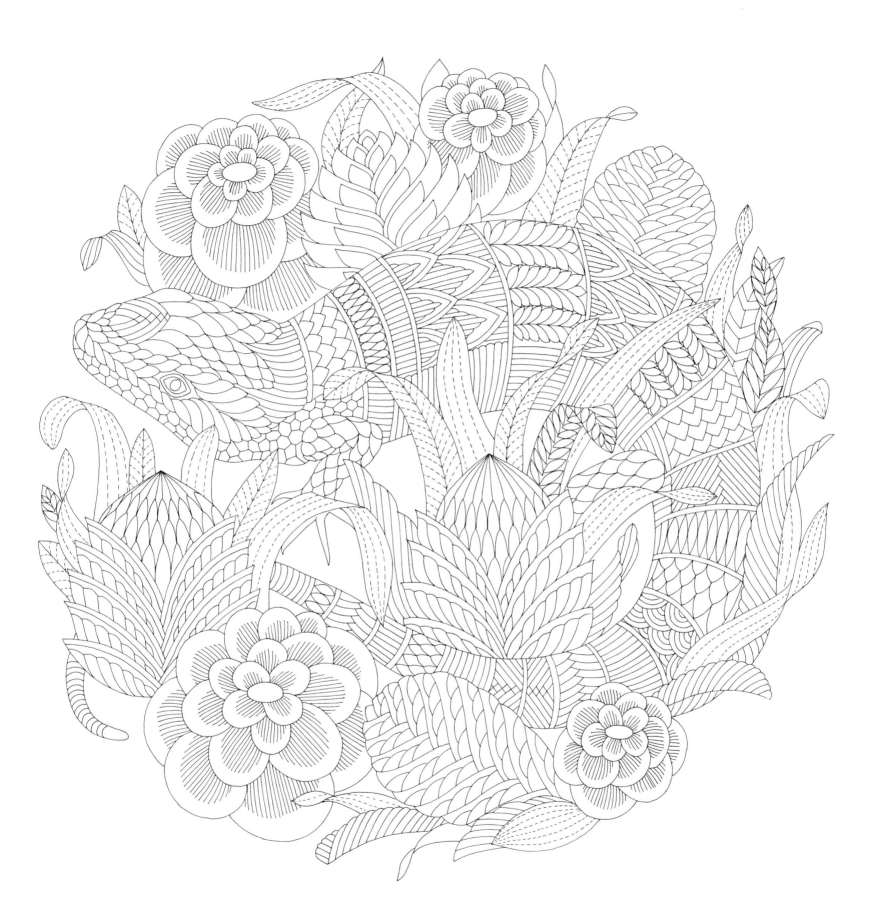

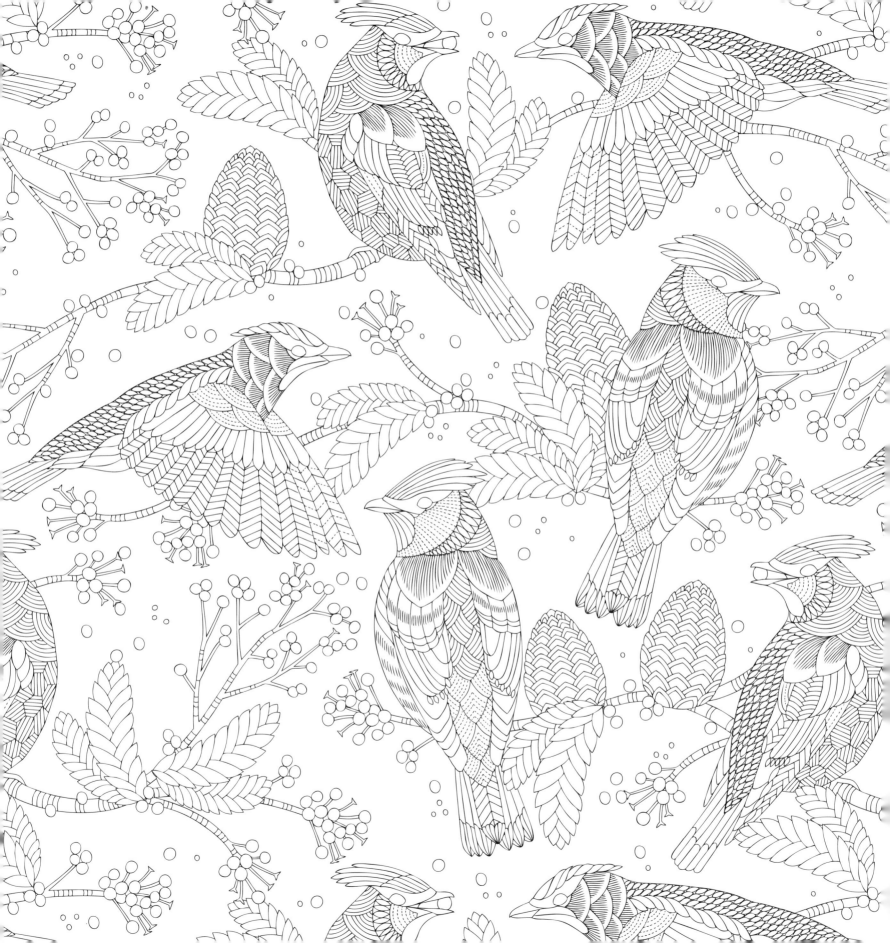

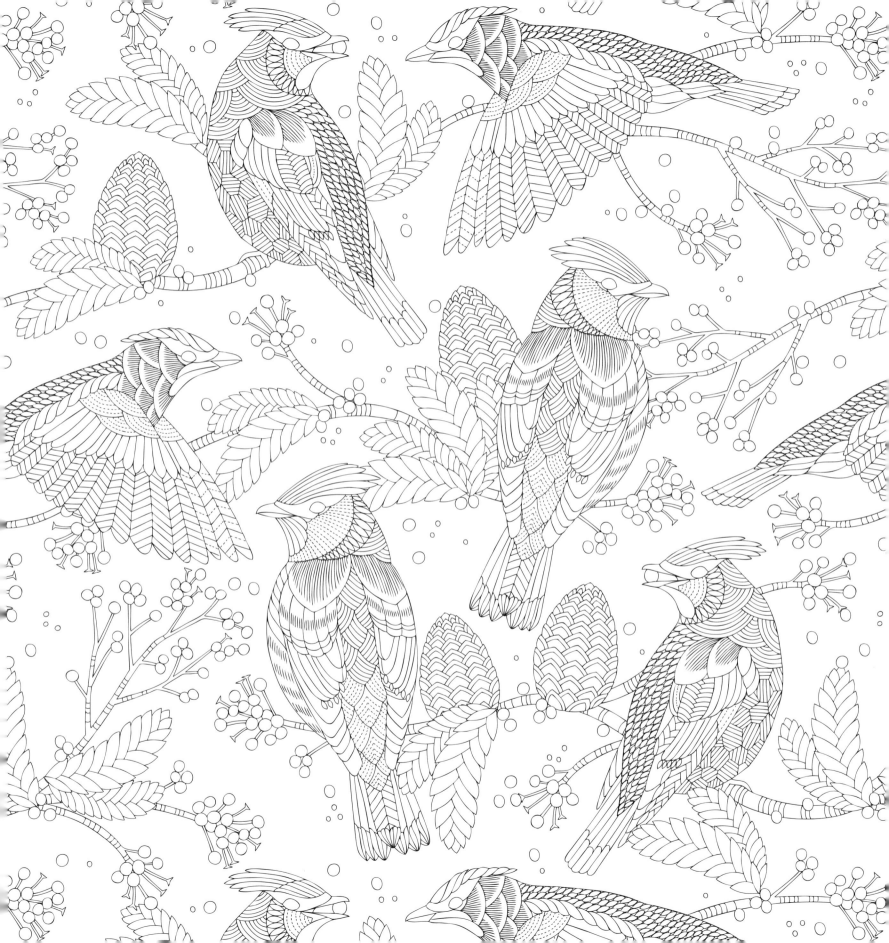

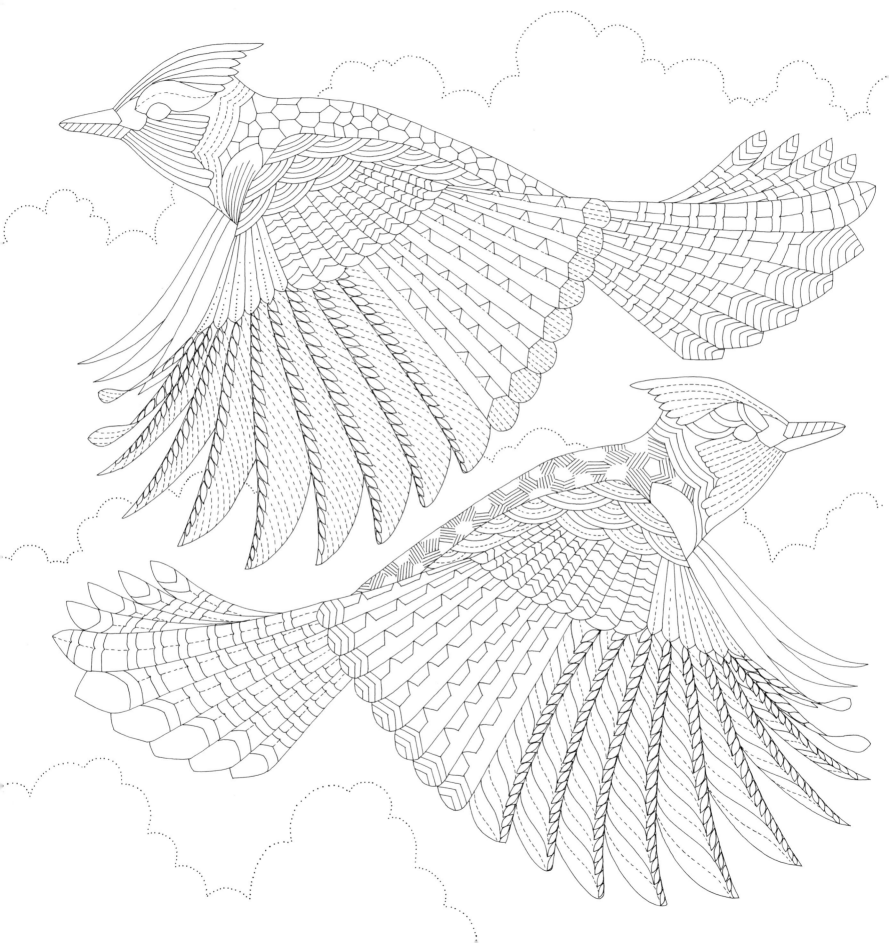

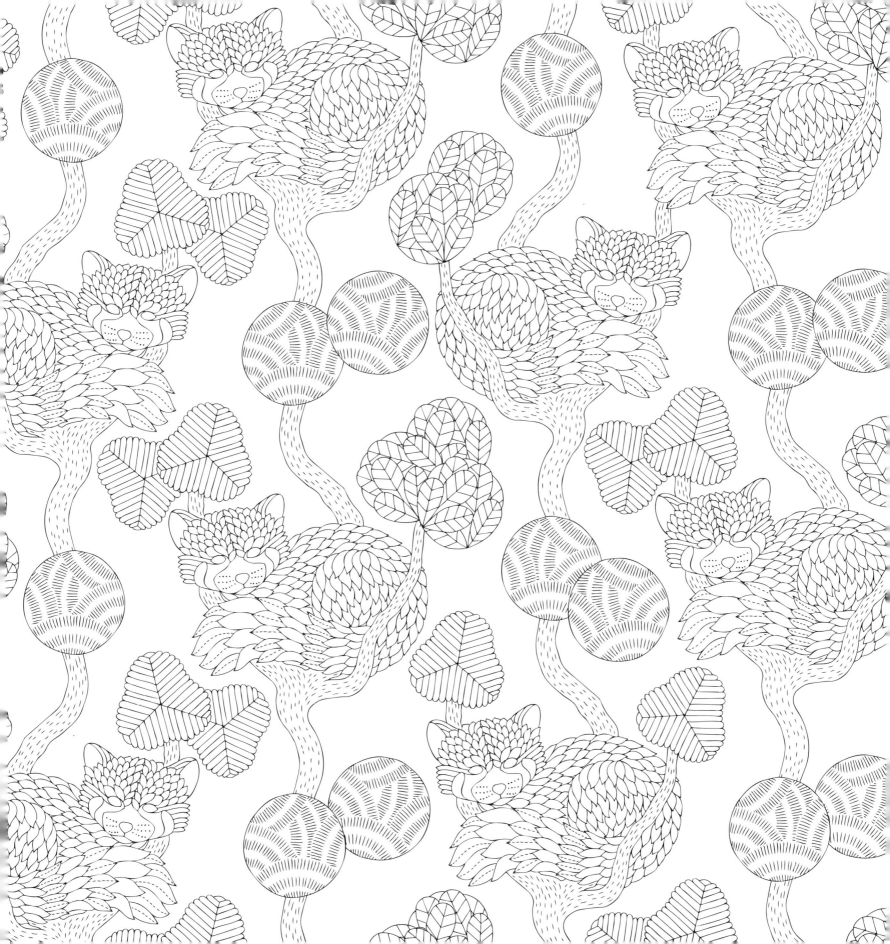

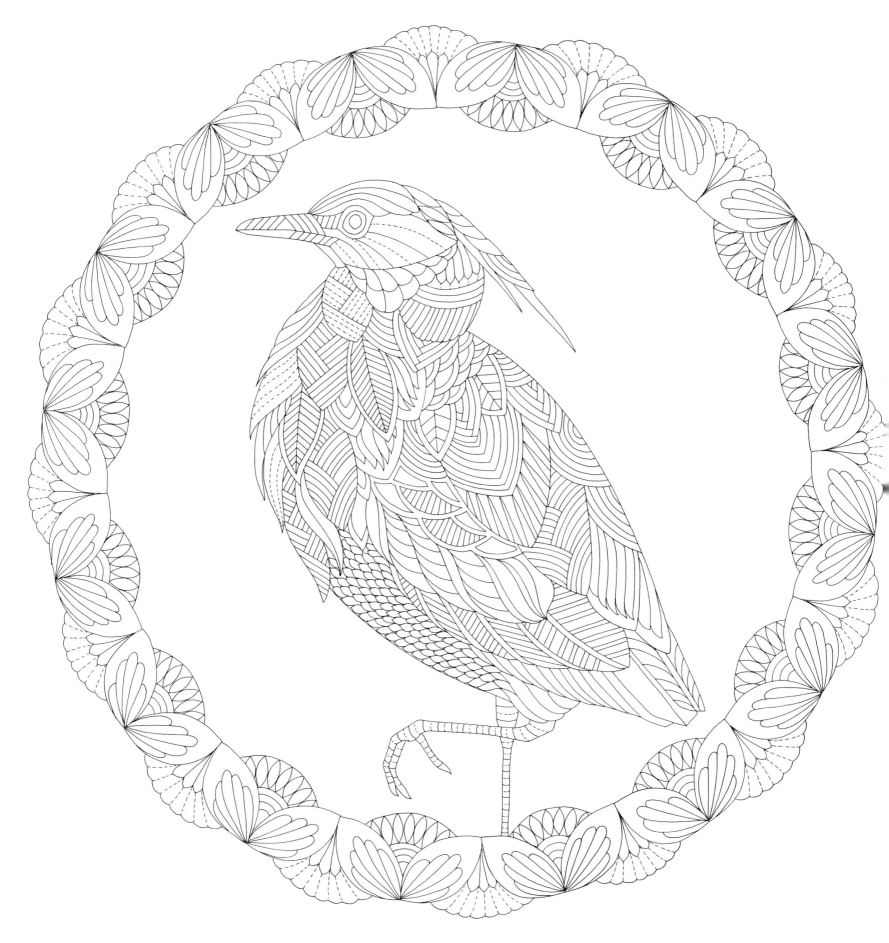

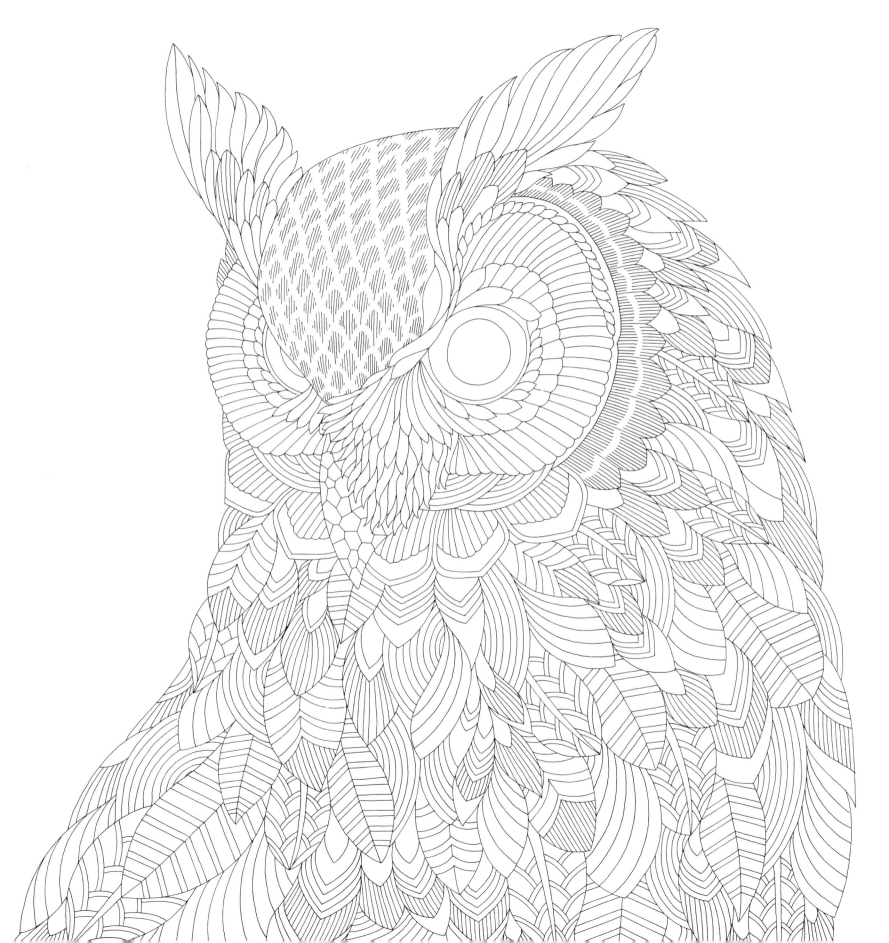

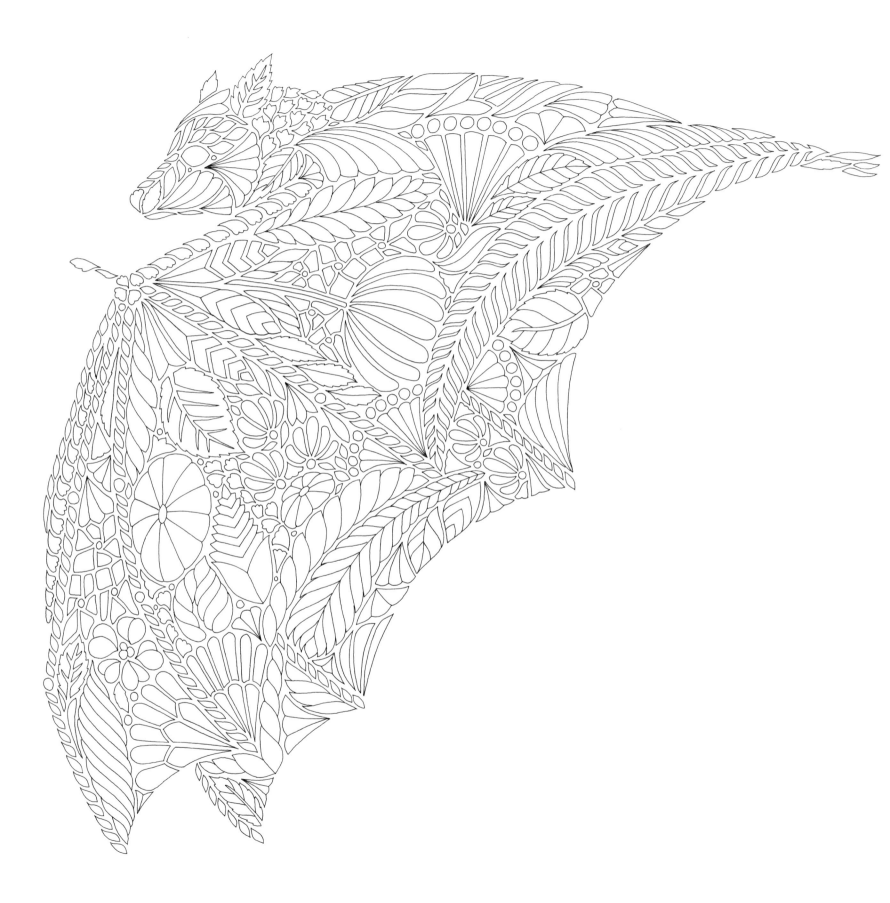

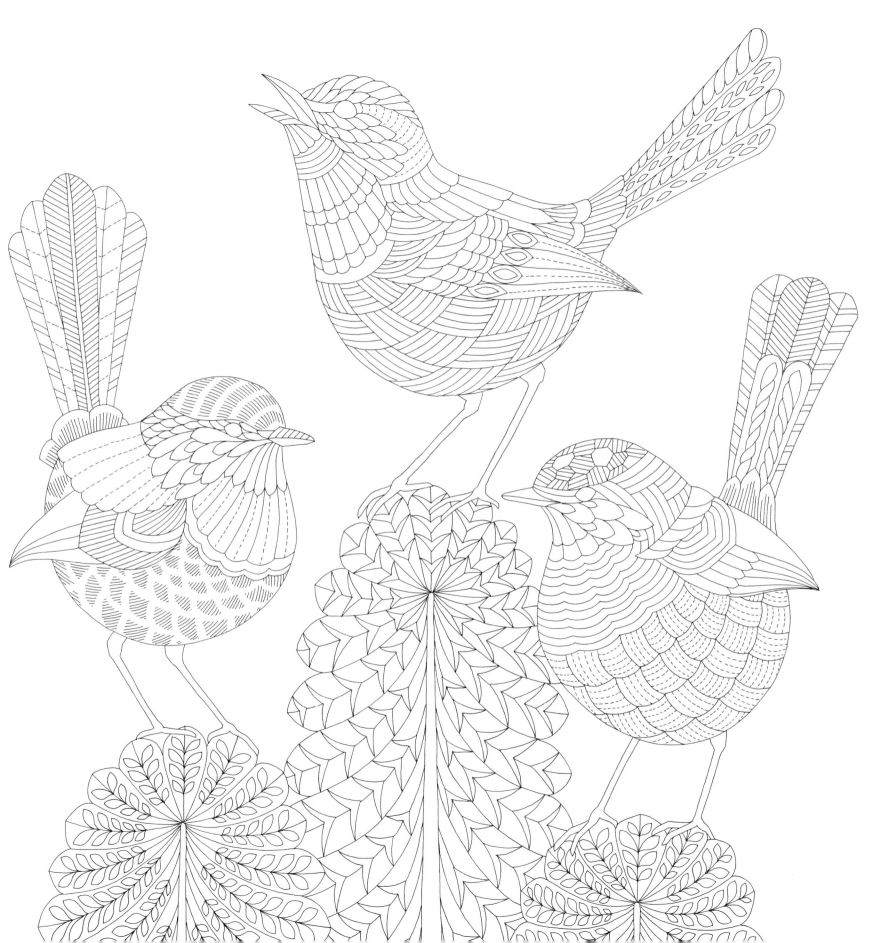

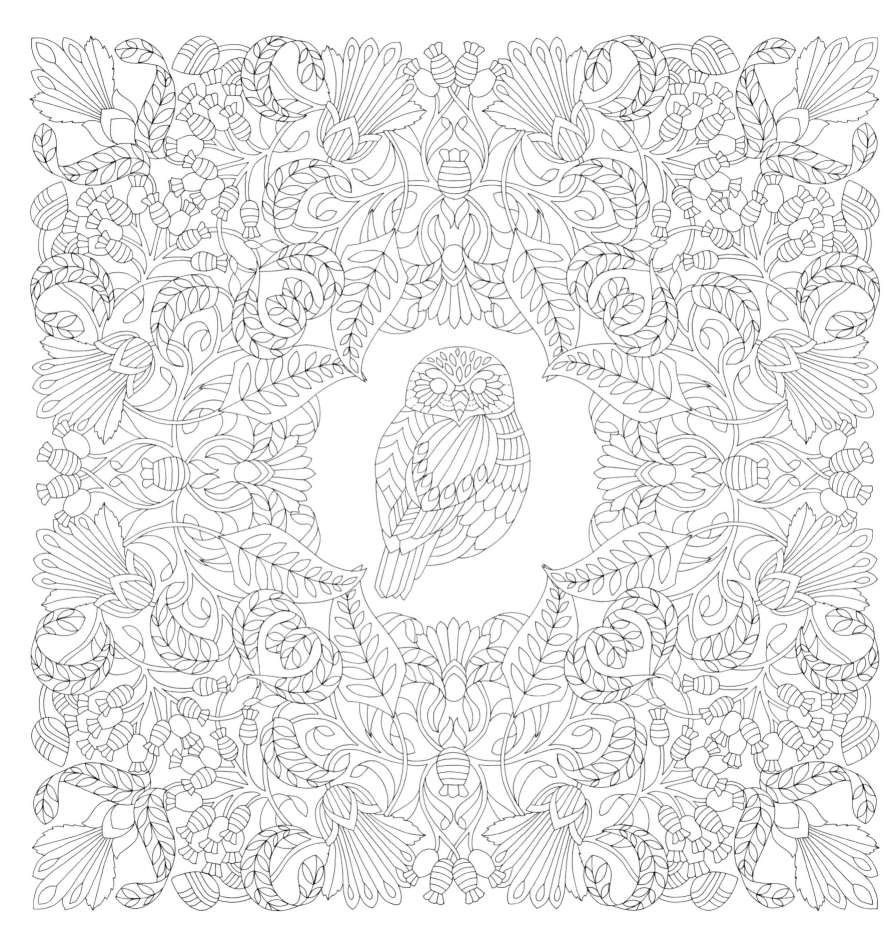

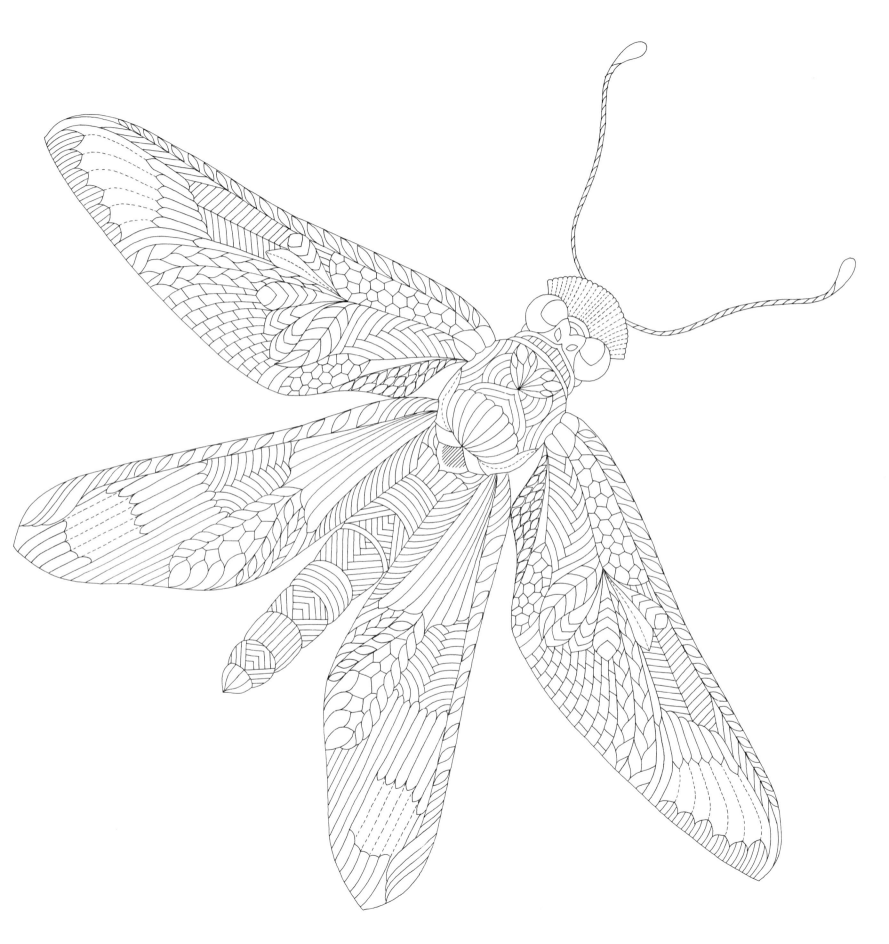

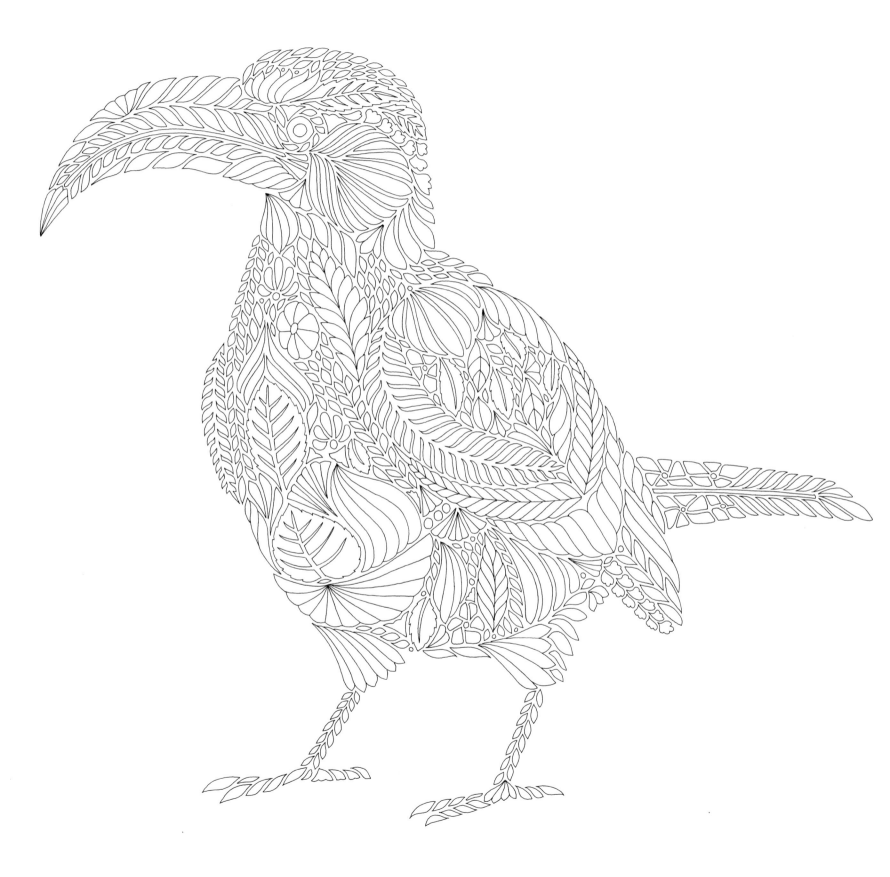

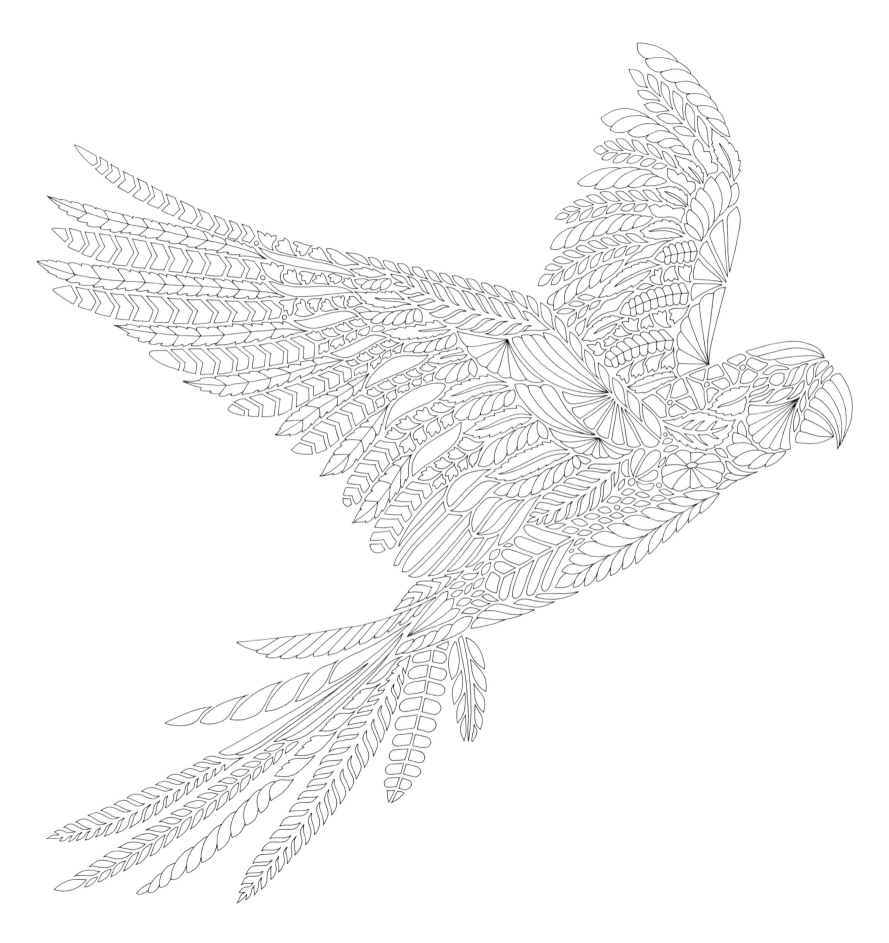

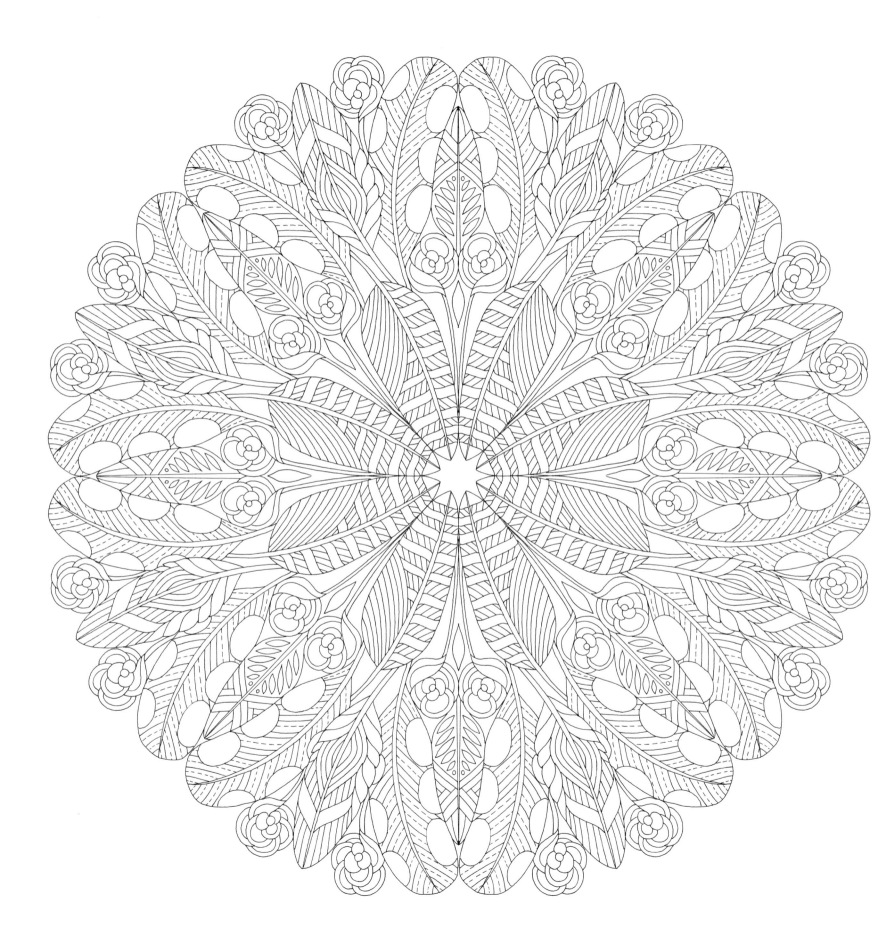

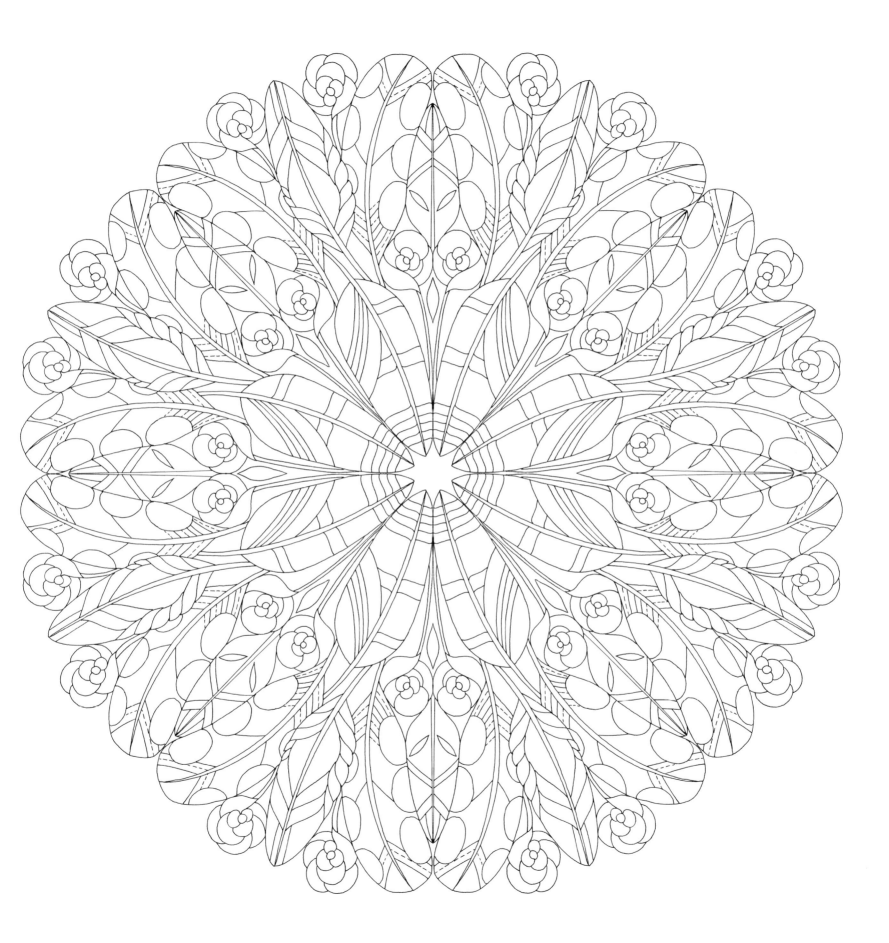

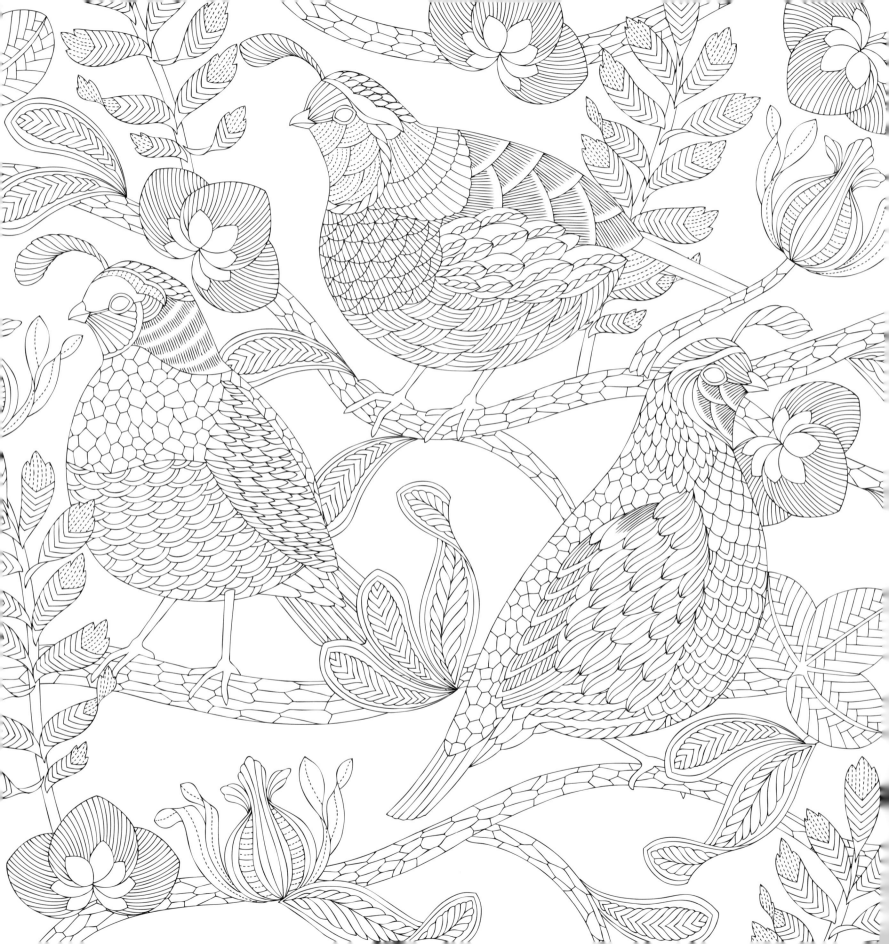

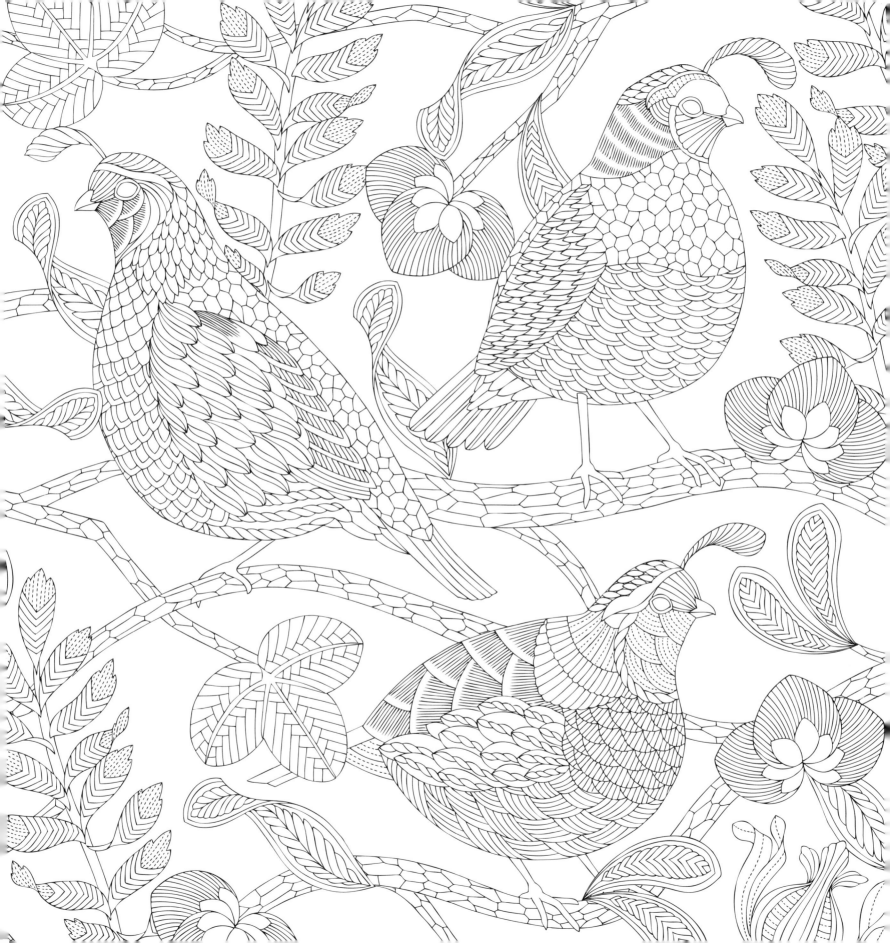

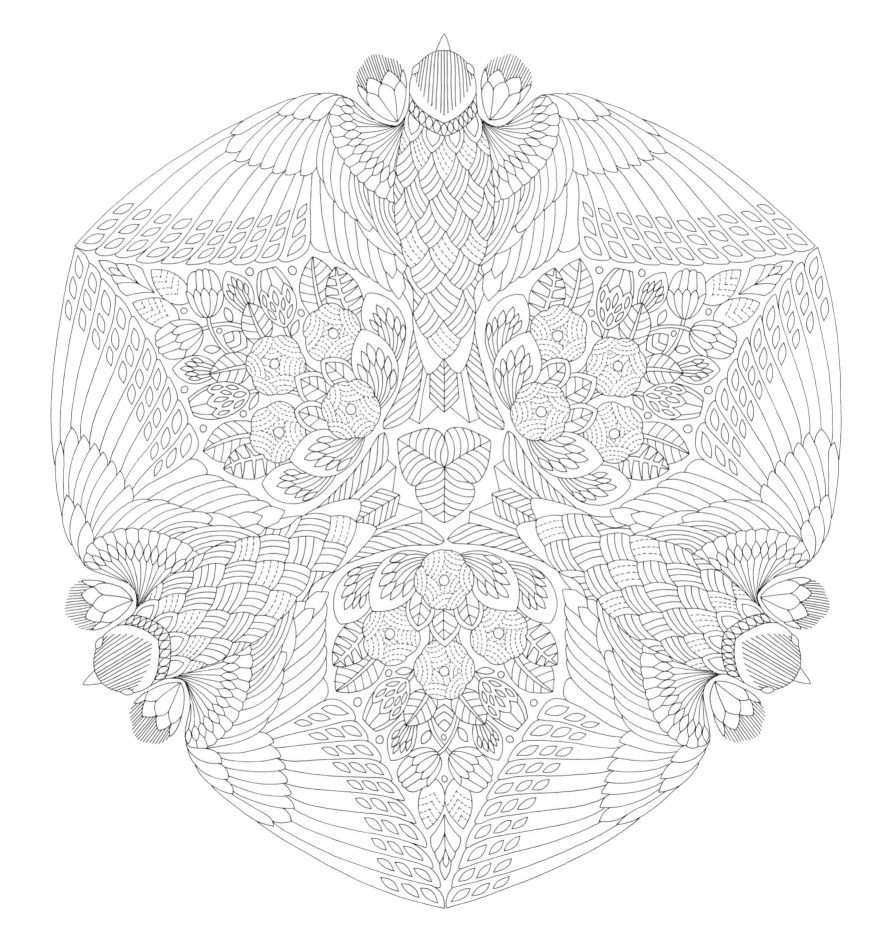

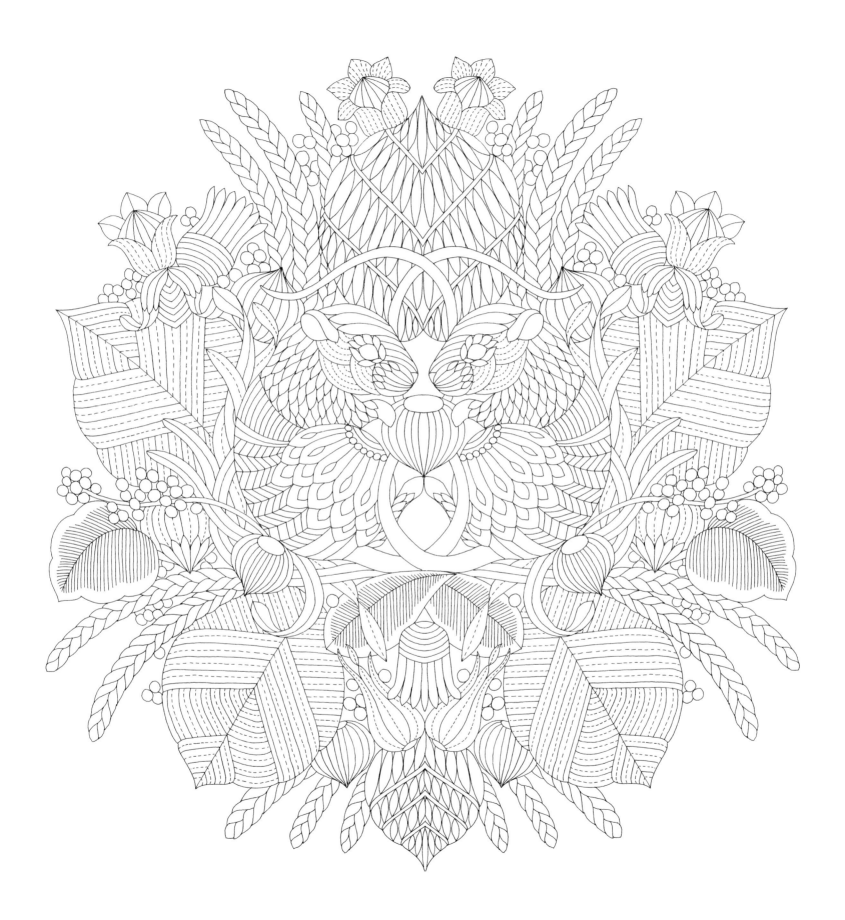

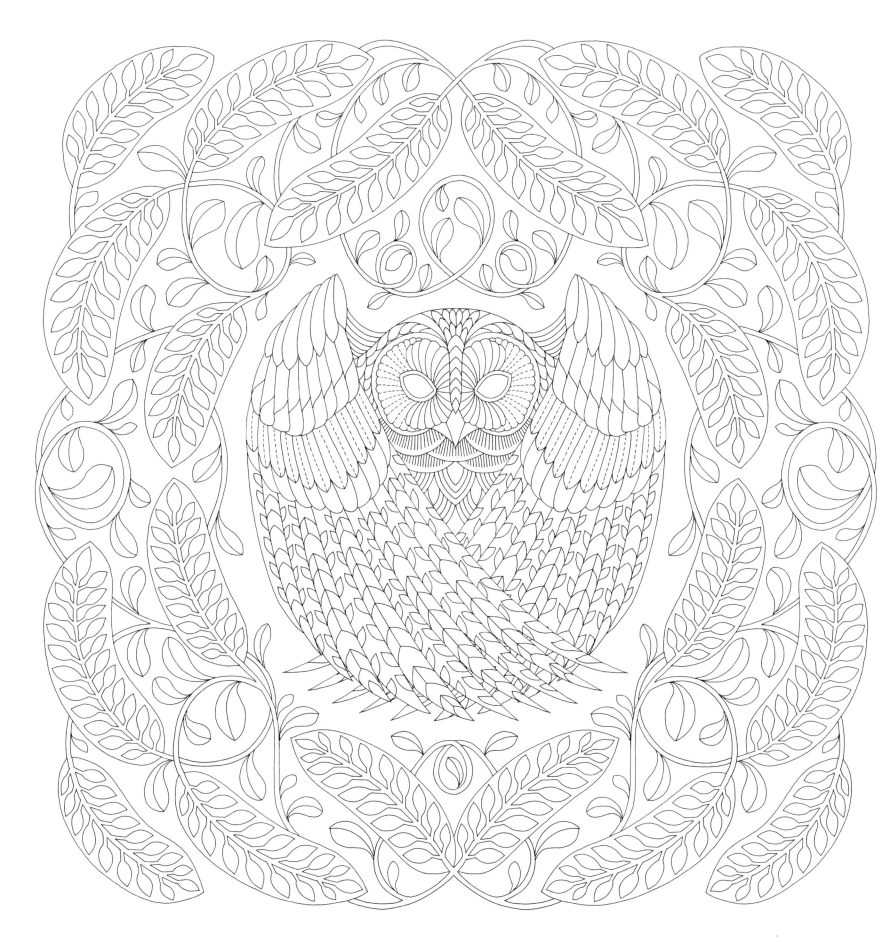

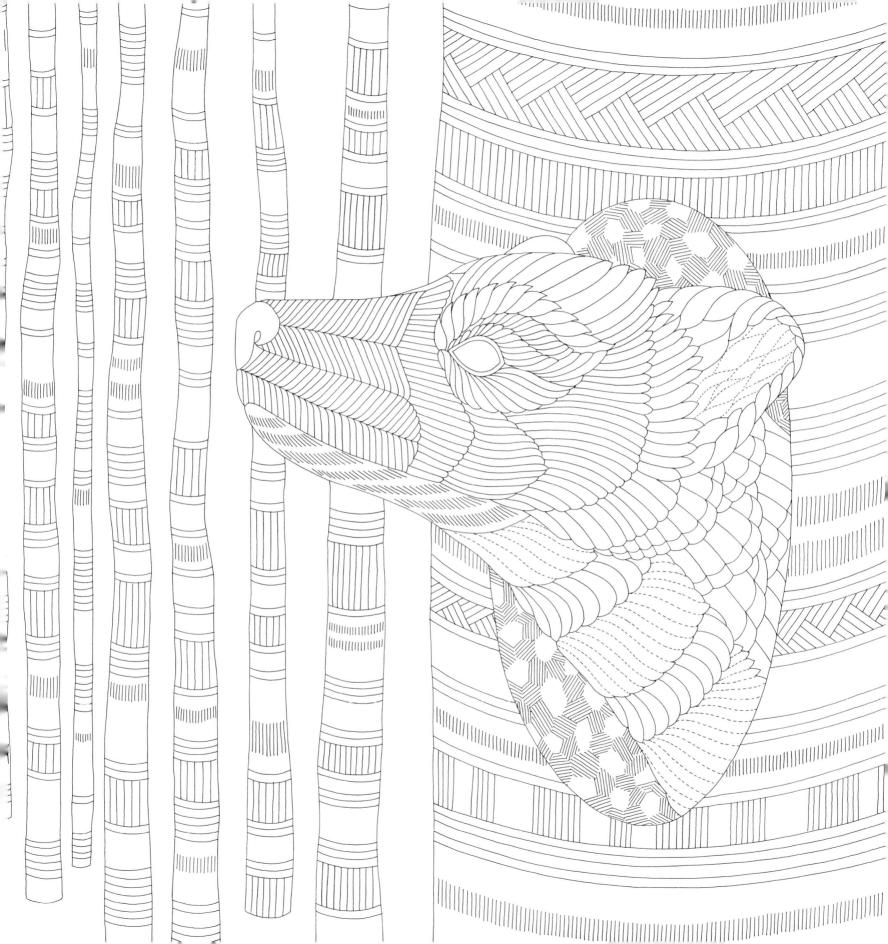

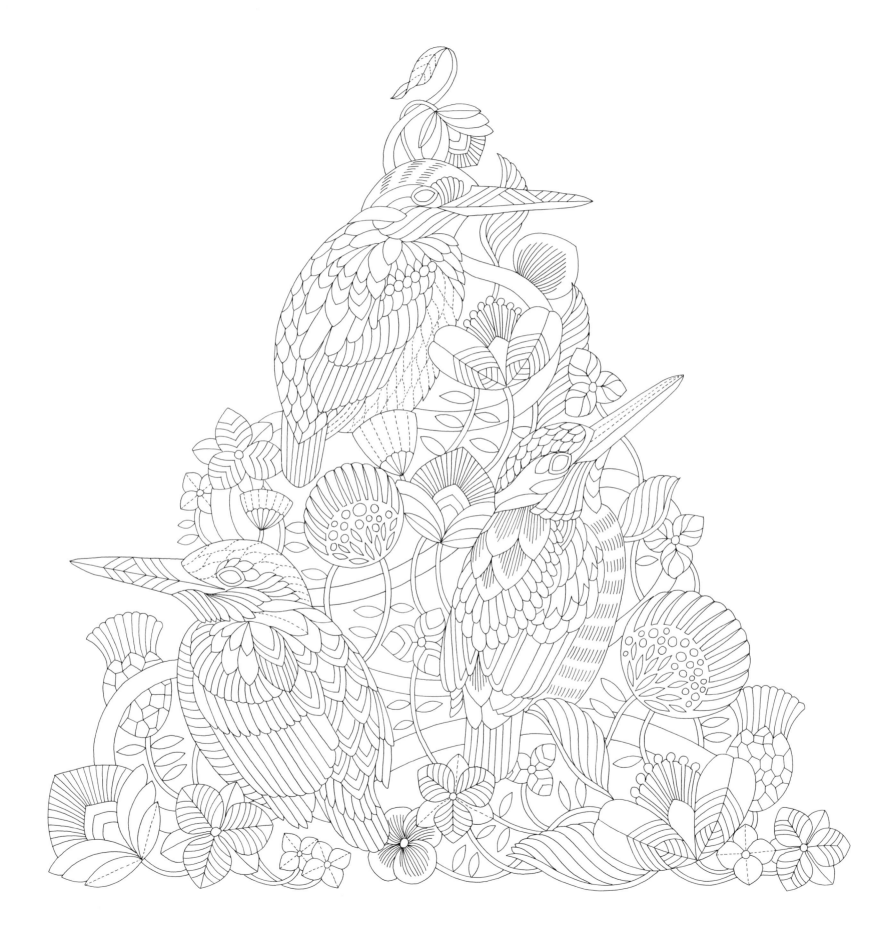

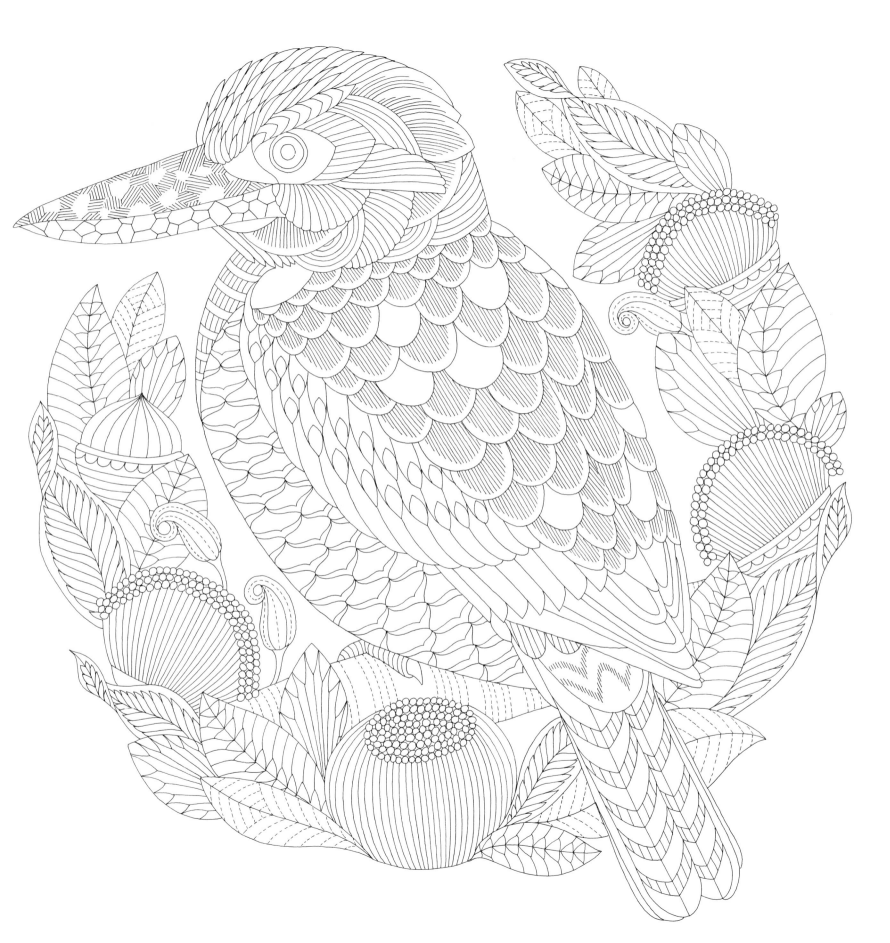

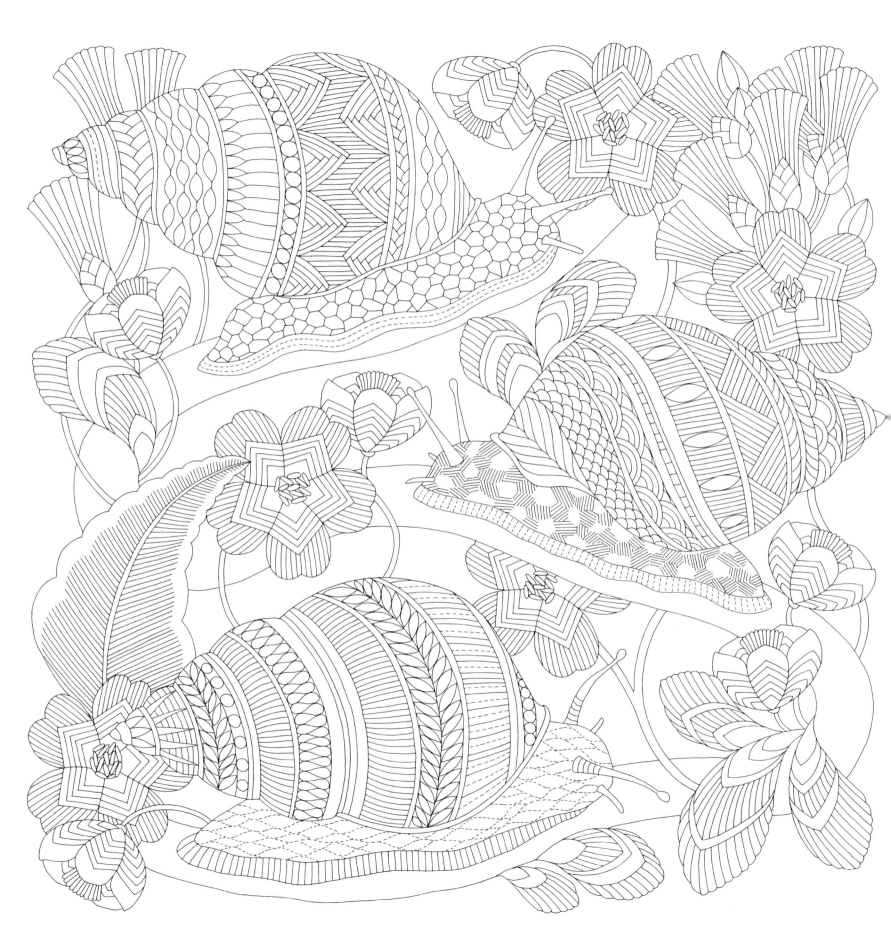

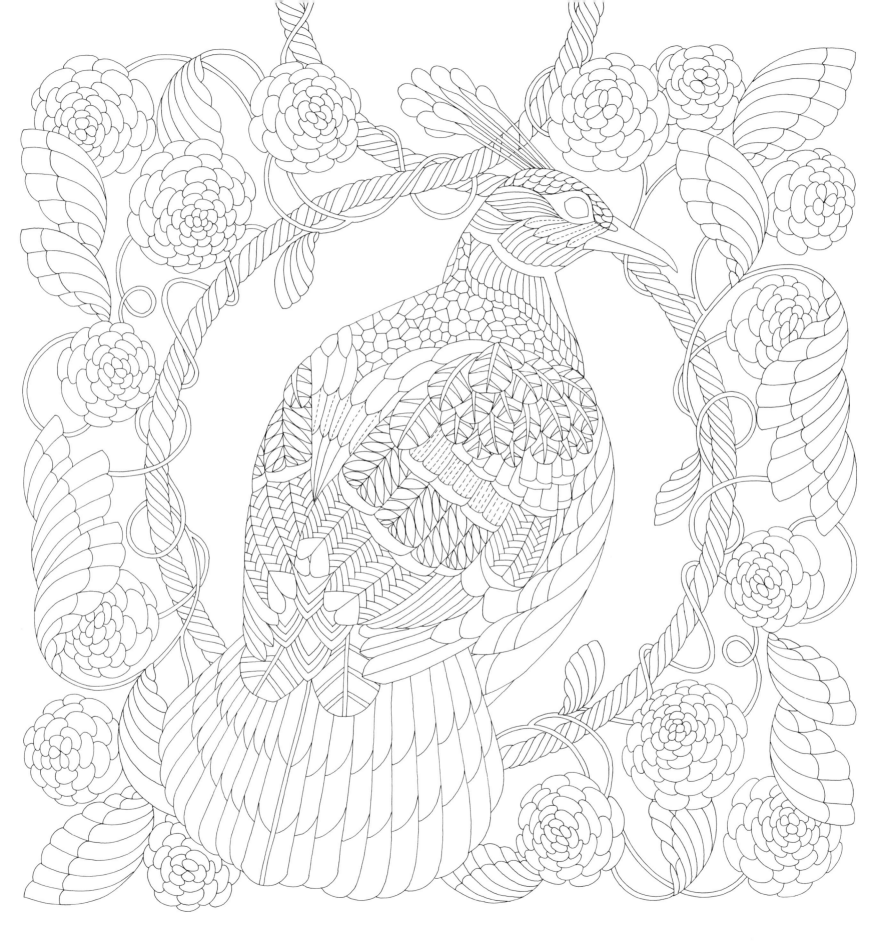

Beautiful Birds and Treetop Treasures

Superb lyrebird
Menura novaehollandiae

Silver-eared mesias
Leiothrix argentauris

Koala
Phascolarctos cinereus

Blue-crowned trogons
Trogon curucui

Agami heron
Agamia agami

Anna's hummingbird
Calypte anna

Northern tamanduas
Tamandua mexicana

Rose robins
Petroica rosea

Grey peacock-pheasant
Polyplectron bicalcaratum

Zebra finches
Taeniopygia guttata

Eurasian blue tits
Cyanistes caeruleus
Coal tits
Periparus ater

Eurasian red squirrel
Sciurus vulgaris

Indian peafowl
Pavo cristatus

Budgerigars
Melopsittacus undulatus

Scarlet ibis
Eudocimus ruber

Satin bowerbird
Ptilonorhynchus violaceus

Eurasian wren
Troglodytes troglodytes

Paradise tree snake
Chrysopelea paradisi

Major Mitchell's
 cockatoos
Lophochroa leadbeateri

Veiled chameleon
Chamaeleo calyptratus

Cicada
Magicicada spp.

Northern flicker
Colaptes auratus

Whiskered treeswifts
Hemiprocne comata

Numbats
Myrmecobius fasciatus

Magnolia warbler
Setophaga magnolia

Common blackbird
Turdus merula

Eurasian nuthatches
Sitta europaea

Seven-spot ladybird
Coccinella septempunctata

Long-tailed tits
Aegithalos caudatus

Hummingbirds
Marvelous spatuletail
Loddigesia mirabilis
Ruby-throated
 hummingbird
Archilochus colubris
Tufted coquette
Lophornis ornatus
Bee hummingbirds
Mellisuga helenae
Red-tailed comet
Sappho sparganurus
Violet-tailed sylph
Aglaiocercus coelestis
Crimson topaz
Topaza pella

Spotted pardalotes
Pardalotus punctatus

Golden eagle
Aquila chrysaetos

Common firecrests
Regulus ignicapilla

Green-headed tanagers
Tangara seledon

American black bear
Ursus americanus

Tree kangaroos
Dendrolagus spp.

Great hornbill
Buceros bicornis
Knobbed hornbill
Aceros cassidix
Rufous-necked hornbill
Aceros nipalensis

Hoopoe
Upupa epops

Sugar glider
Petaurus breviceps

Roseate spoonbills
Platalea ajaja

Tui
Prosthemadera novaeseelandiae

Wolf's mona monkey
Cercopithecus wolfi

Vulturine guinea fowl
Acryllium vulturinum

King bird-of-paradise
Cicinnurus regius

Butterflies
White-spotted agrias
Agrias amydon
Janetta Themis forester
Euphaedra janetta
Apollo metalmark
Lyropteryx apollonia

Northern cardinals
Cardinalis cardinalis

Five-spot burnets
Zygaena trifolii

Eurasian bullfinch
Pyrrhula pyrrhula

Spruce grouse
Falcipennis canadensis

Amazon milk frogs
Trachycephalus resinifictrix

Lily moth
Polytela gloriosae

Arboreal alligator lizard
Abronia graminea

Cedar waxwings
Bombycilla cedrorum

Blue jays
Cyanocitta cristata

Red pandas
Ailurus fulgens

Malayan night heron
Gorsachius melanolophus

Eurasian eagle owl
Bubo bubo

Flying fox
Pteropus spp.

Splendid fairy wrens
Malurus splendens

Pygmy owl
Glaucidium spp.

Owlfly
Ascalaphidae spp.

Southern yellow-billed
 hornbill
Tockus leucomelas

Scarlet macaw
Ara macao

Feathers
Eurasian jay
Garrulus glandarius
Great spotted
 woodpecker
Dendrocopos major

Golden pheasant
Chrysolophus pictus
King bird-of-paradise
Cicinnurus regius
Rosy-faced lovebird
Agapornis roseicollis

California quail
Callipepla californica

Tree swallows
Tachycineta bicolor

Dormice
Gliridae spp.

Tawny owl
Strix aluco

European pine marten
Martes martes

Rufous-backed
 kingfishers
Ceyx rufidorsa

Blue-winged kookaburra
Dacelo leachii

Florida tree snails
Liguus fasciatus

Himalayan monal
Lophophorus impejanus

Create your own beautiful birds and treetop treasures here...